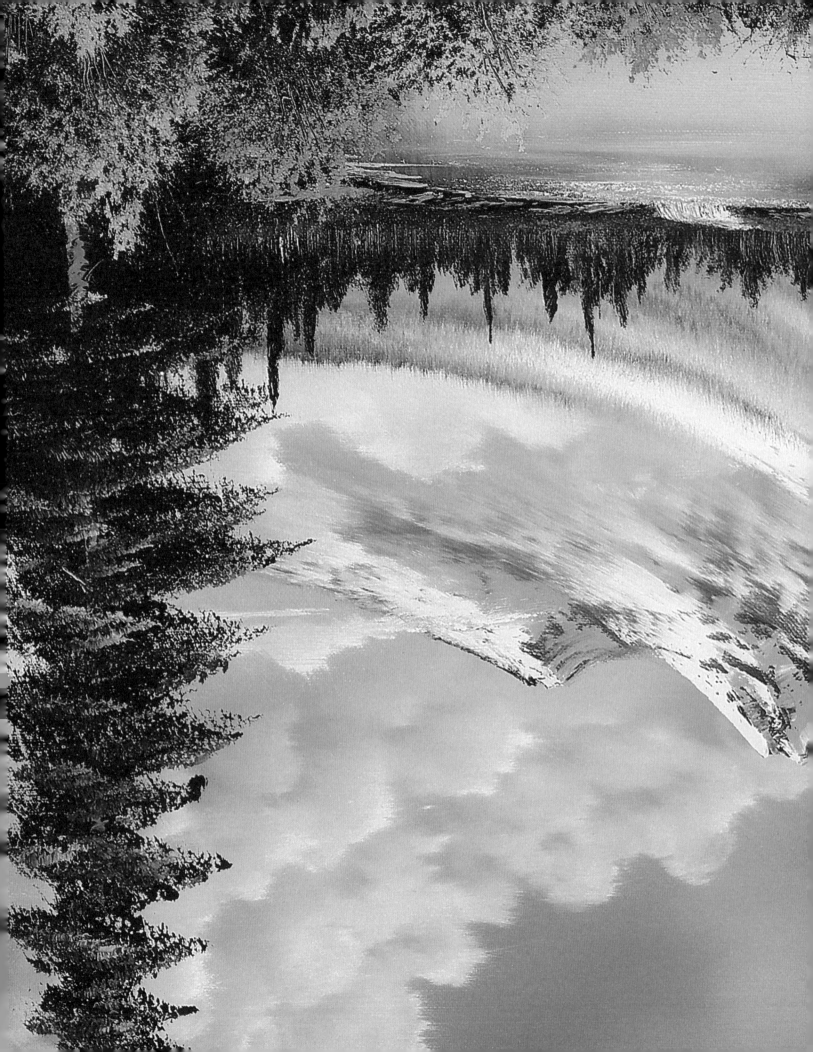

Where's Bob?

A HAPPY LITTLE SEEK-AND-FIND

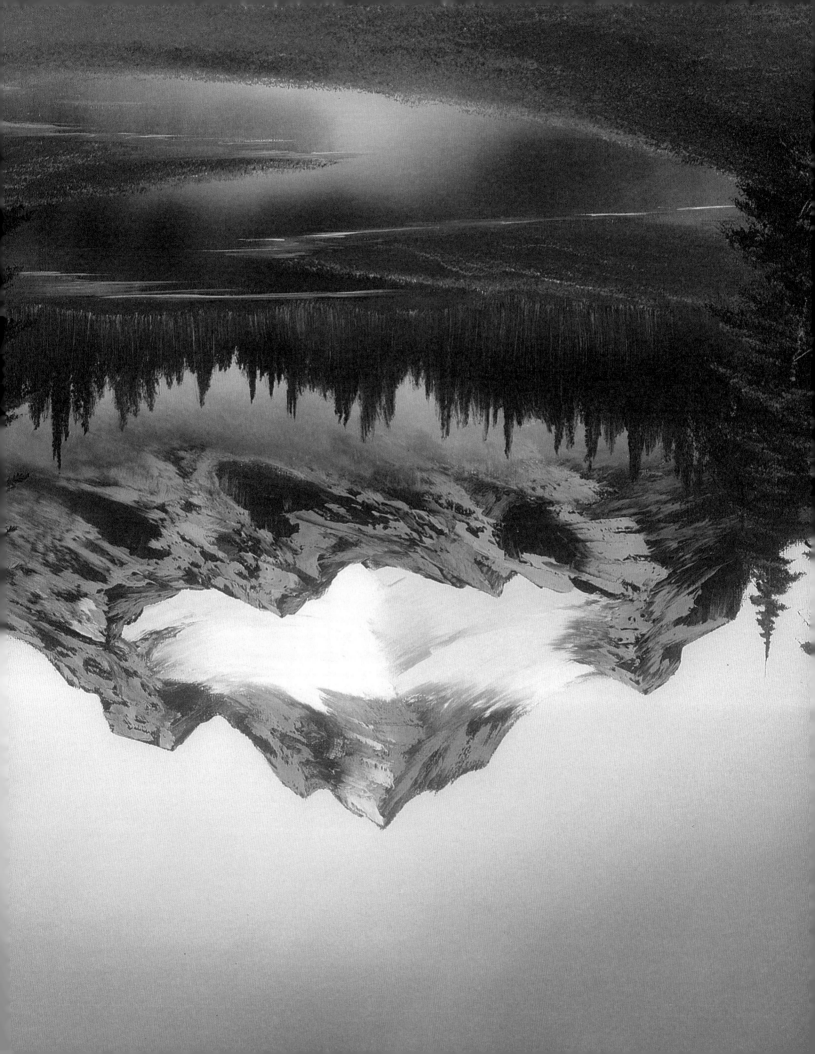

Bob Ross®
Where's Bob?
A HAPPY LITTLE SEEK-AND-FIND

ROBB PEARLMAN

Illustrated by
BILL GREENHEAD

Running Press
PHILADELPHIA

© 2022 Bob Ross Inc. Bob Ross® name and images
are registered trademarks of Bob Ross Inc.

Hachette Book Group supports the right to free expression and the value of copyright.
The purpose of copyright is to encourage writers and artists to produce
the creative works that enrich our culture.

The scanning, uploading, and distribution of this book without permission
is a theft of the author's intellectual property. If you would like permission to use material
from the book (other than for review purposes), please contact permissions@hbgusa.com.
Thank you for your support of the author's rights.

Running Press
Hachette Book Group
1290 Avenue of the Americas,
New York, NY 10104
www.runningpress.com
@Running_Press

Printed in Italy

First Edition: November 2022

Published by Running Press, an imprint of Perseus Books, LLC,
a subsidiary of Hachette Book Group, Inc. The Running Press name and logo
are trademarks of the Hachette Book Group.

The Hachette Speakers Bureau provides a wide range of authors for speaking events.
To find out more, go to www.hachettespeakersbureau.com or call (866) 376-6591.

The publisher is not responsible for websites (or their content) that are not owned by the publisher.

Print book cover and interior design by Frances J. Soo Ping Chow.
Print book cover and interior illustrations by Bill Greenhead.

Library of Congress Control Number: 2022934327

ISBN: 978-0-7624-8057-9 (hardcover), 978-0-7624-8361-7 (ebook)

Elco

10 9 8 7 6 5 4 3 2 1

Contents

Where's Bob? .. 7

TV Studio ... 8

Lazy River .. 10

Seaside ... 12

Mountain Range .. 14

Nightscape .. 16

Lush Forest ... 18

Shopping Mall ... 20

Rolling Hills ... 22

Dense Forest .. 24

Wildflower Field .. 26

Animal Friends .. 28

The Woods ... 30

Air Force Base .. 32

Florida Wetlands .. 34

Where's Bob? .. 36

Checklists .. 38

Key ... 39

About the Author .. 48

About the Illustrator ... 48

Where's Bob?

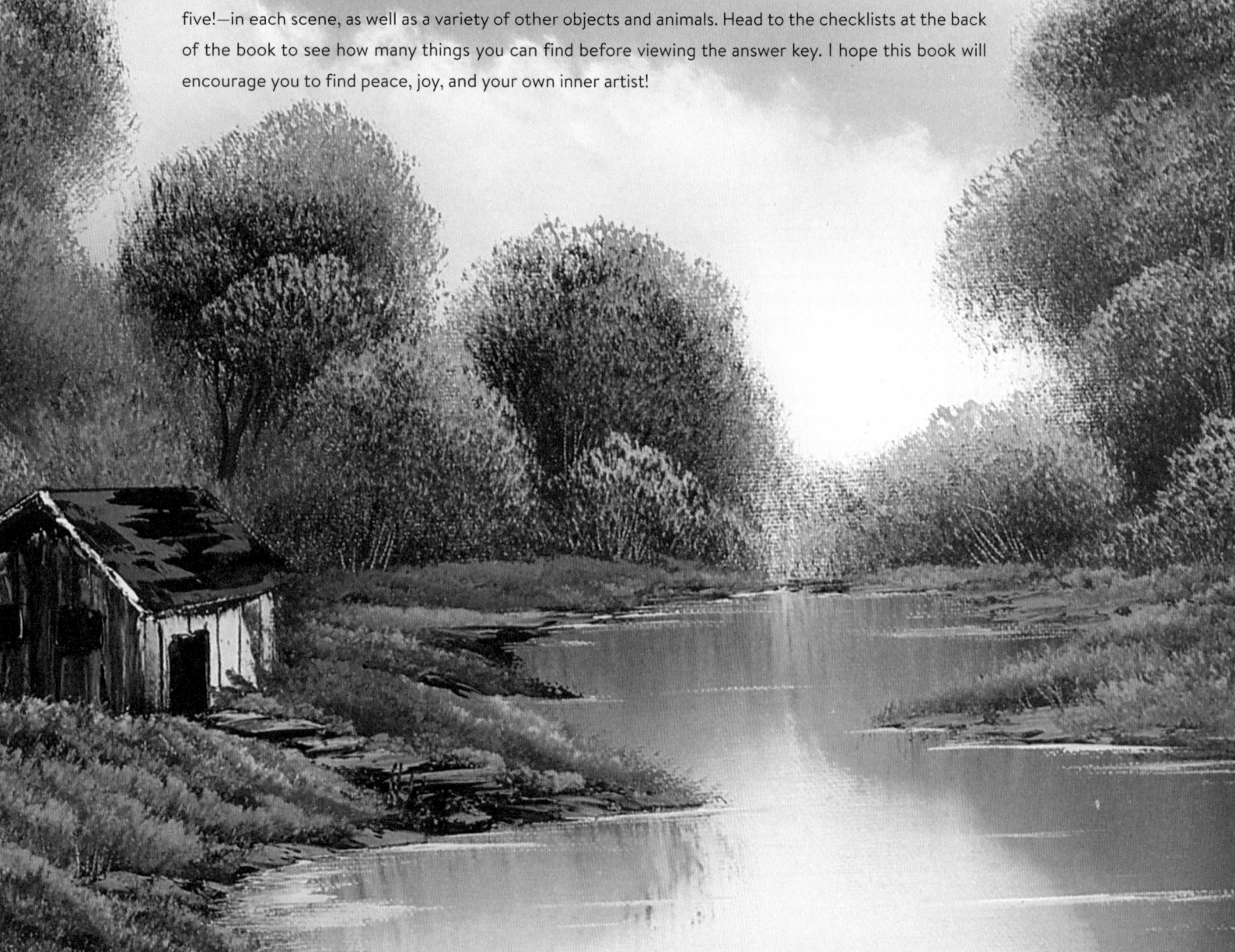

From 1942 to 1961, Bob Ross could be found in Florida with his brother and best friend, Jimmie. When a woodworking accident derailed Bob's plans to follow in his father's footsteps in becoming a carpenter, he found himself at a crossroads.

Bob eventually enlisted in the US Air Force and was stationed in Eielson Air Force Base in Alaska. It was there, surrounded by the beautiful Alaskan landscape, that he became inspired to paint.

Bob discovered a teacher, mentor, and friend in Bill Alexander, whose televised learn-to-paint show inspired Bob to try and perfect his wet-on-wet painting technique—applying layers of oil paint on top of layers that are still wet. After several years of practice, teaching, and finding his own unique voice and style, Bob began teaching classes of his own: first in person at community centers and malls and then on his very own show, *The Joy of Painting*.

Starting in 1982, *The Joy of Painting* could be found only on your local public television stations, but nowadays, the show—and Bob—can be found wherever there's a screen and an internet connection!

Though Bob passed away in 1995, he can still be found in the hearts, minds, and creative spirit of millions of people. A constant source of inspiration, encouragement, and calm, Bob Ross is also enshrined in a host of tributes, like this book!

On the following pages are fifteen scenes where you can find five images of Bob—that's right, five!—in each scene, as well as a variety of other objects and animals. Head to the checklists at the back of the book to see how many things you can find before viewing the answer key. I hope this book will encourage you to find peace, joy, and your own inner artist!

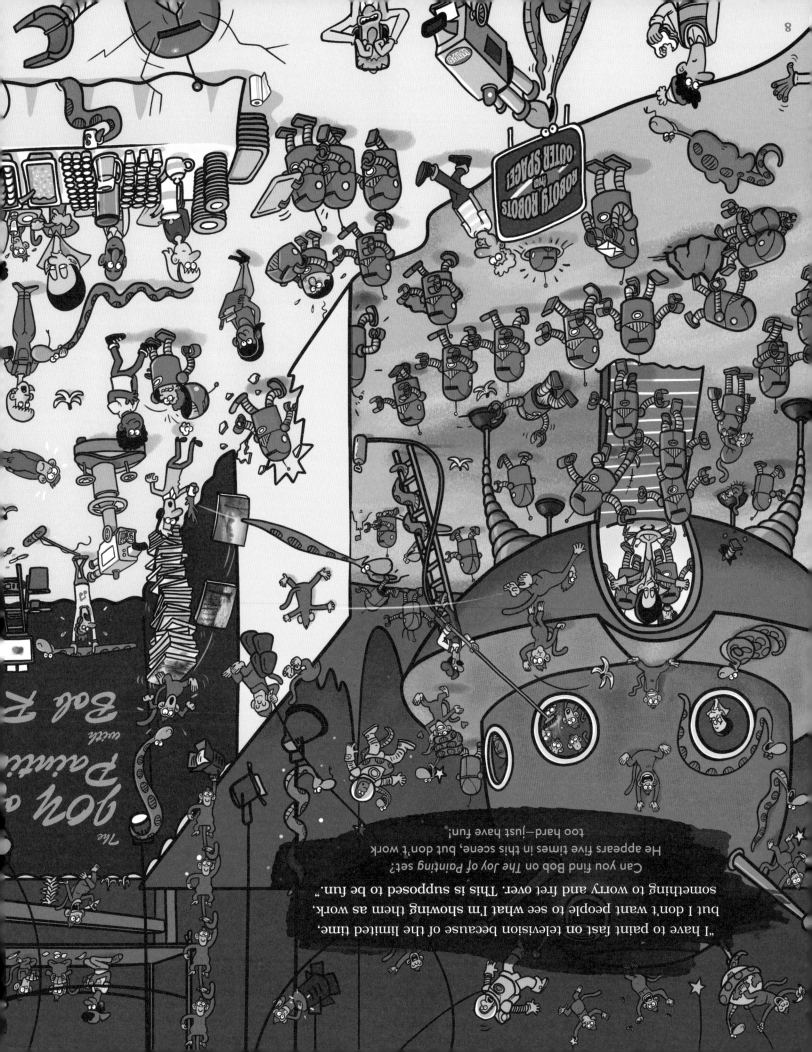

The Joy of Painting with Bob

"I have to paint fast on television because of the limited time, but I don't want people to see what I'm showing them as work, something to worry and fret over. This is supposed to be fun."

Can you find Bob on The Joy of Painting set? He appears five times in this scene, but don't work too hard—just have fun!

ROBOTY ROBOTS from OUTER SPACE!

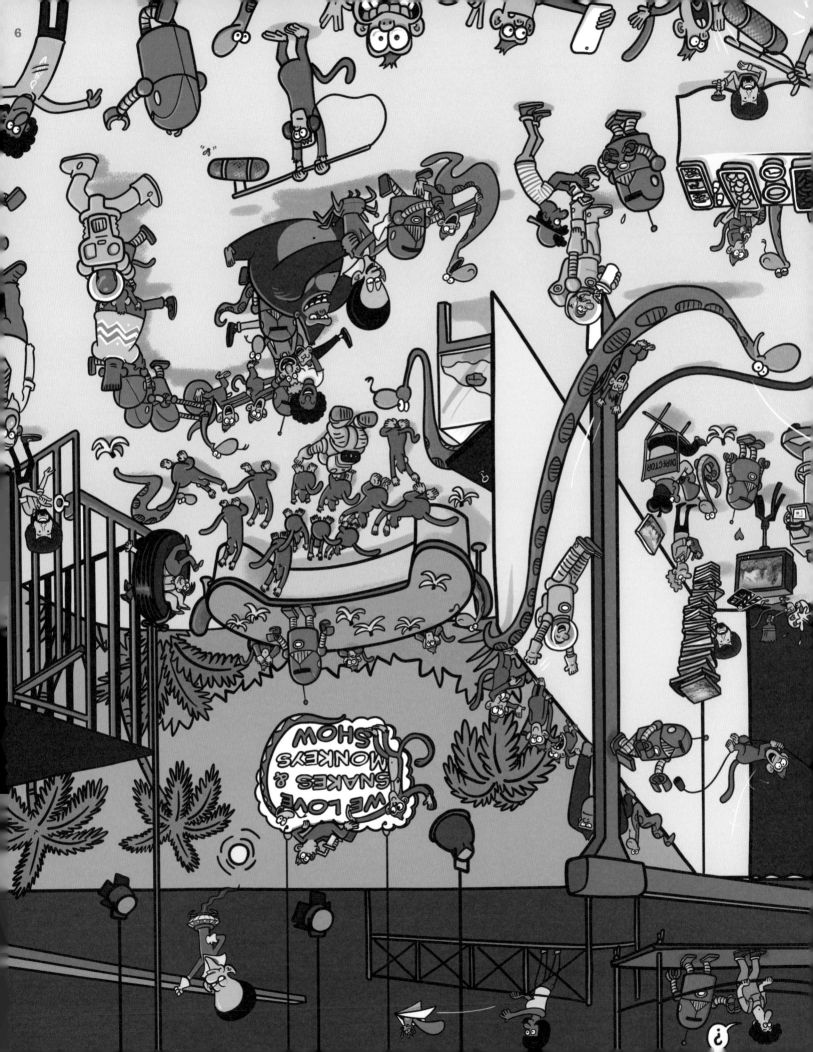

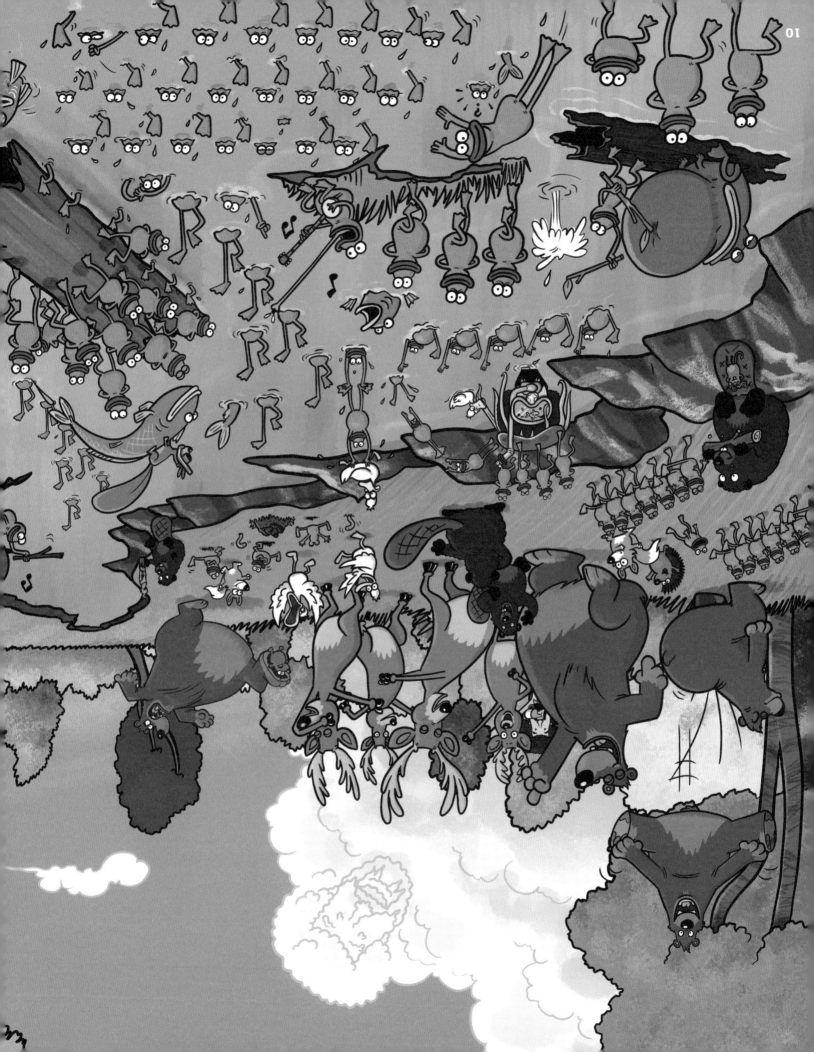

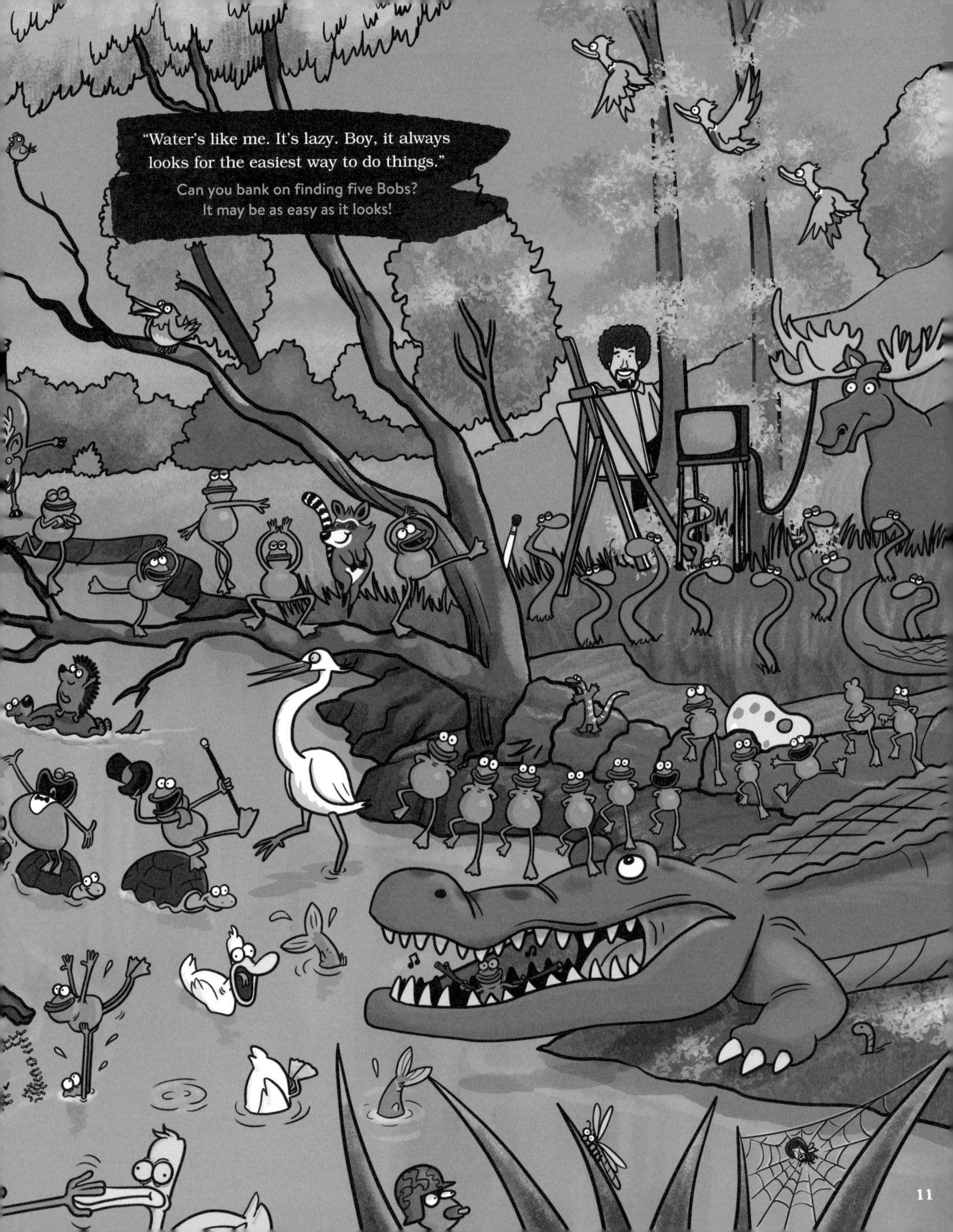

"Water's like me. It's lazy. Boy, it always looks for the easiest way to do things."

Can you bank on finding five Bobs?
It may be as easy as it looks!

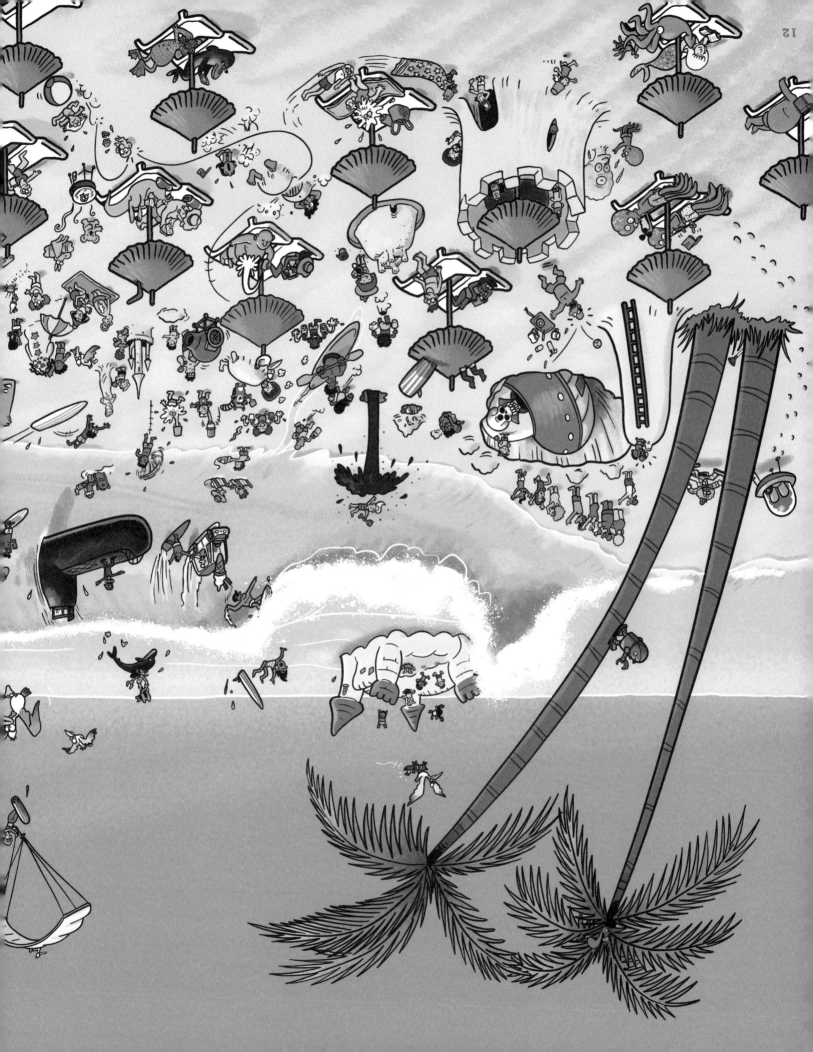

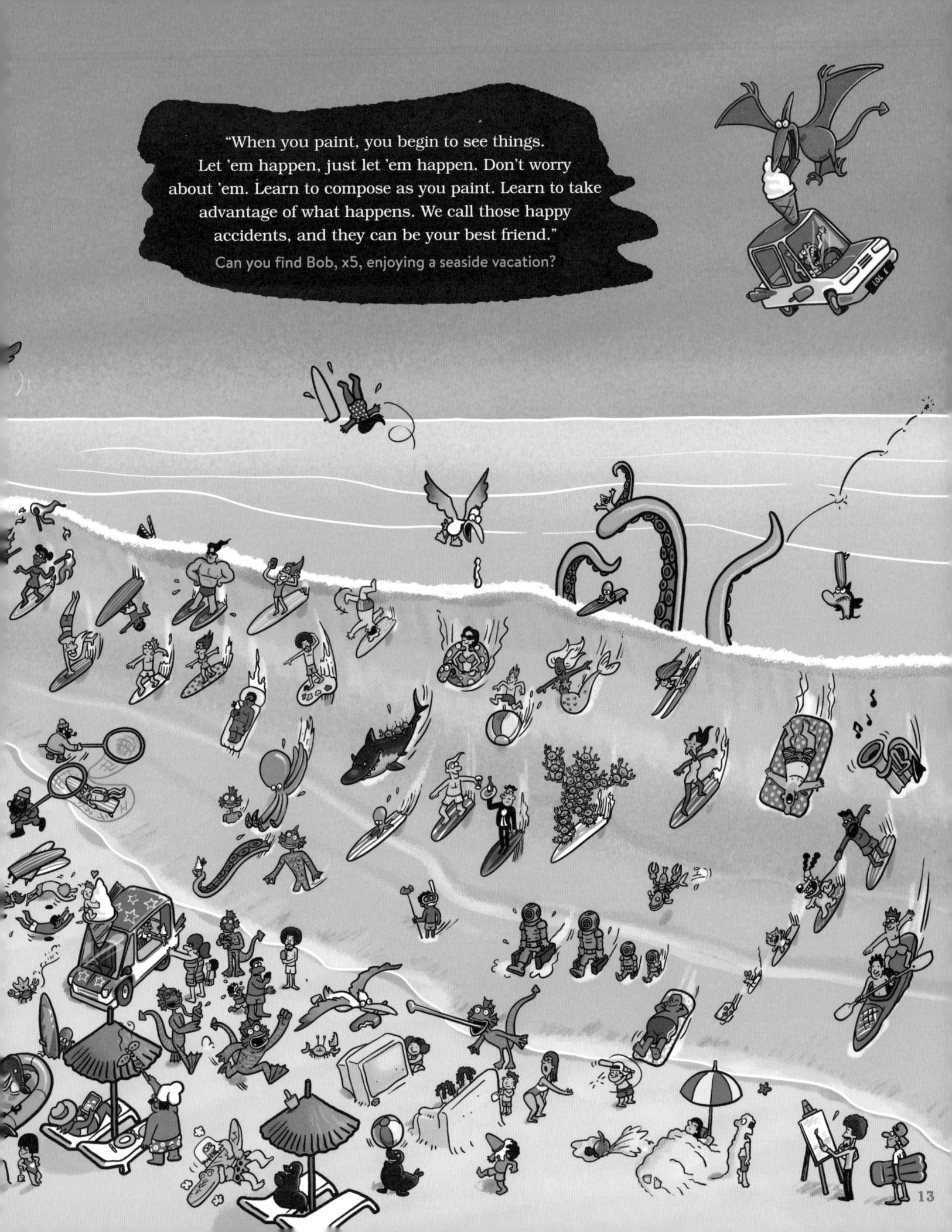

"When you paint, you begin to see things. Let 'em happen, just let 'em happen. Don't worry about 'em. Learn to compose as you paint. Learn to take advantage of what happens. We call those happy accidents, and they can be your best friend."

Can you find Bob, x5, enjoying a seaside vacation?

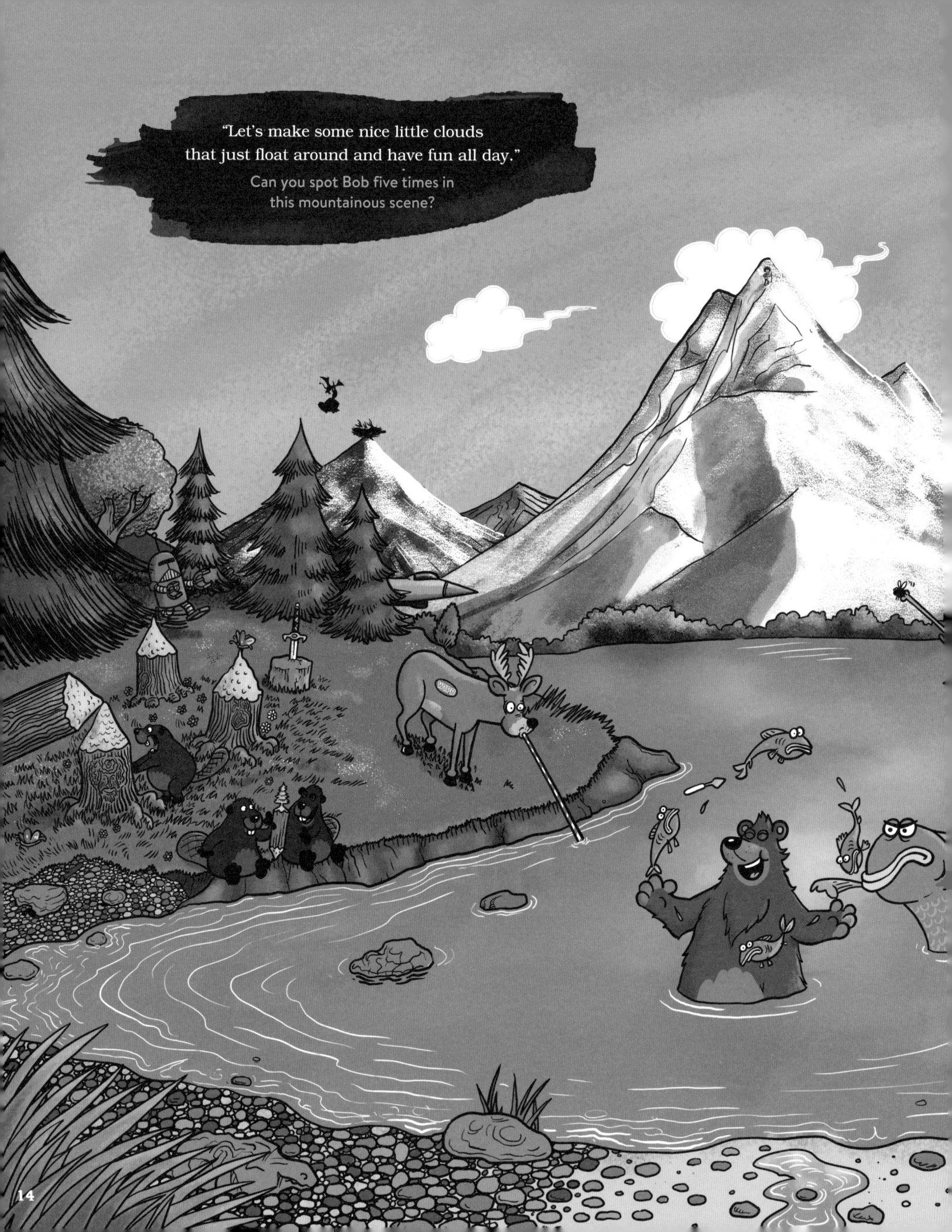

"Let's make some nice little clouds that just float around and have fun all day."

Can you spot Bob five times in this mountainous scene?

14

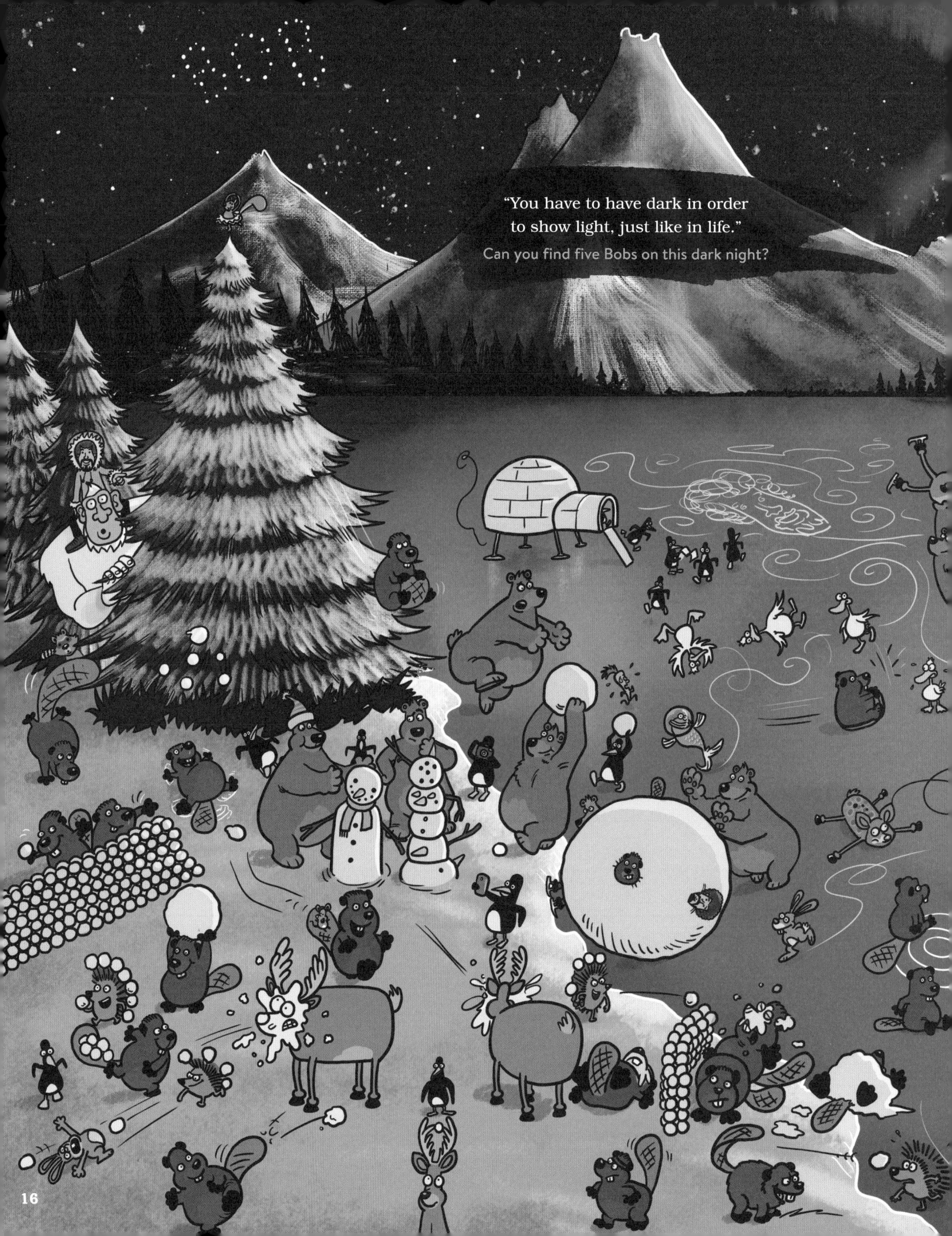

"You have to have dark in order to show light, just like in life."

Can you find five Bobs on this dark night?

16

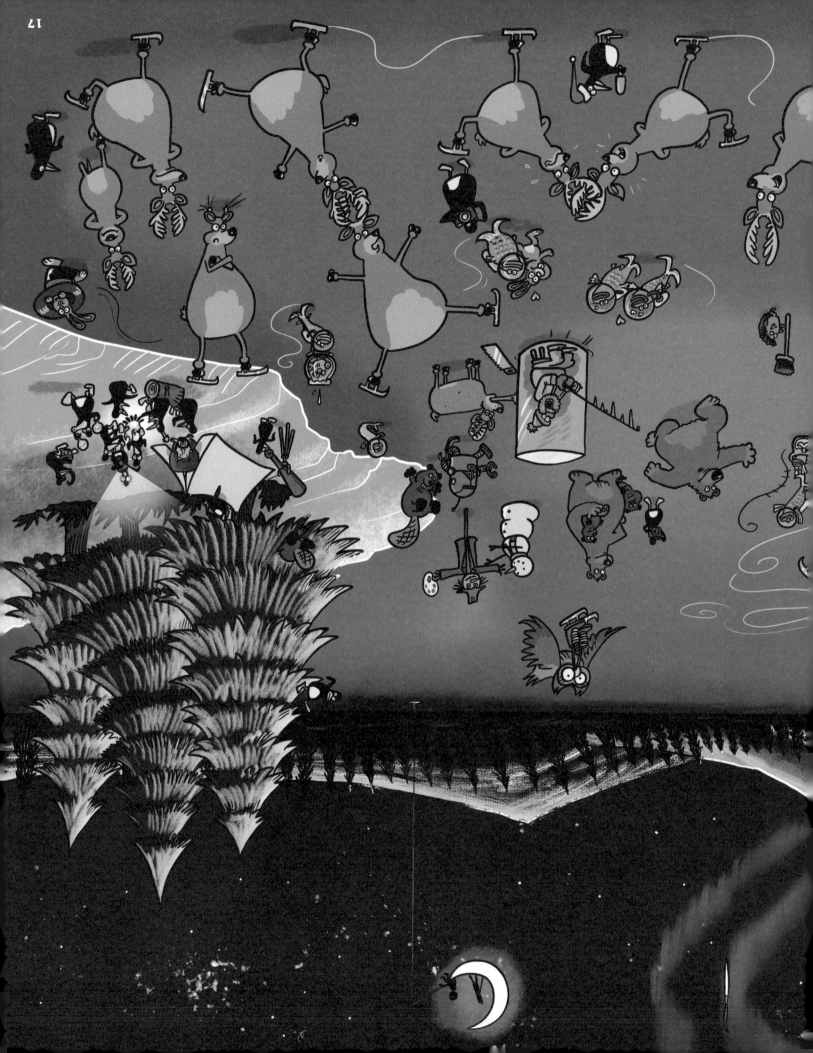

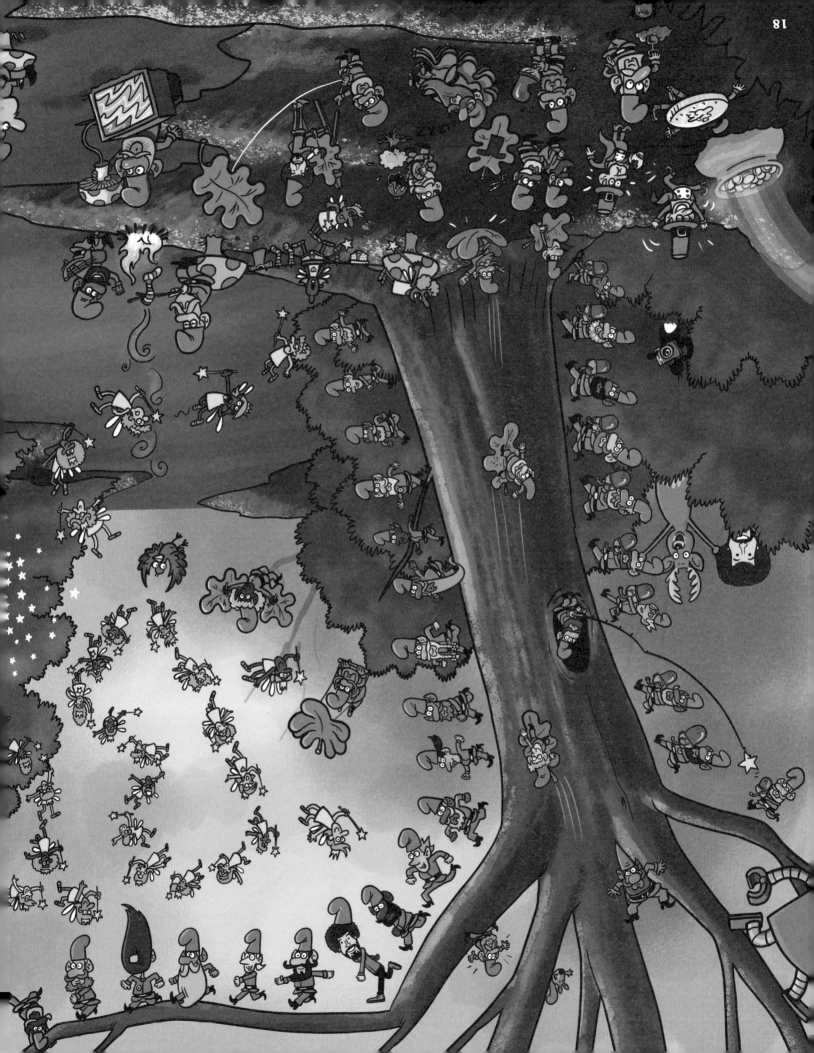

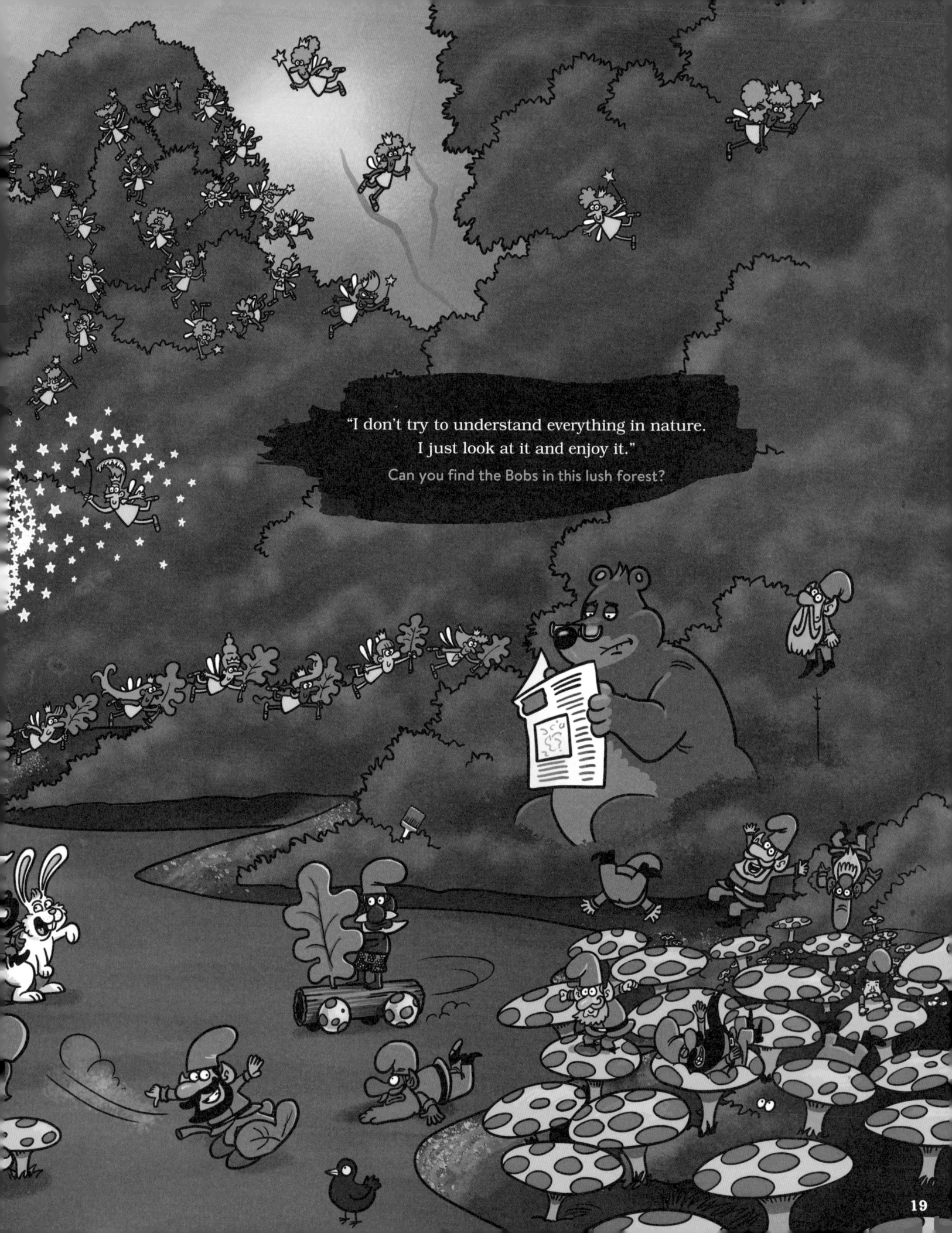

"I don't try to understand everything in nature.
I just look at it and enjoy it."
Can you find the Bobs in this lush forest?

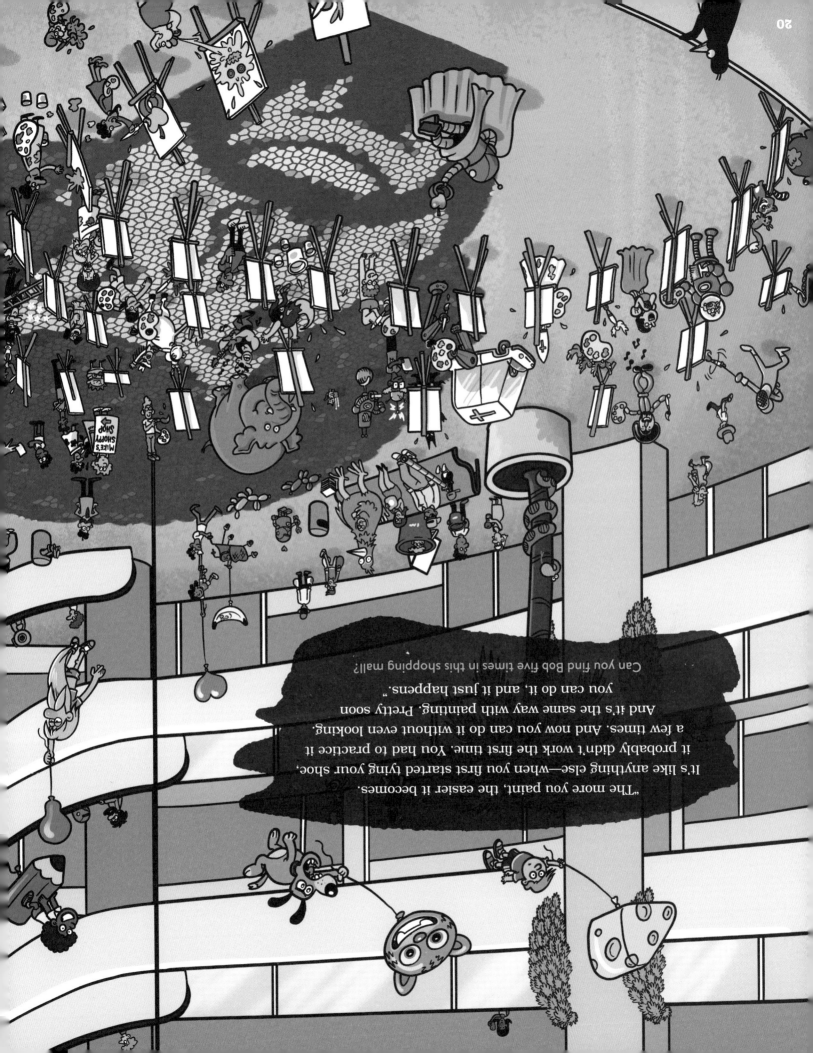

"The more you paint, the easier it becomes.
It's like anything else—when you first started tying your shoe,
it probably didn't work the first time. You had to practice it
a few times. And now you can do it without even looking.
And it's the same way with painting. Pretty soon
you can do it, and it just happens."

Can you find Bob five times in this shopping mall?

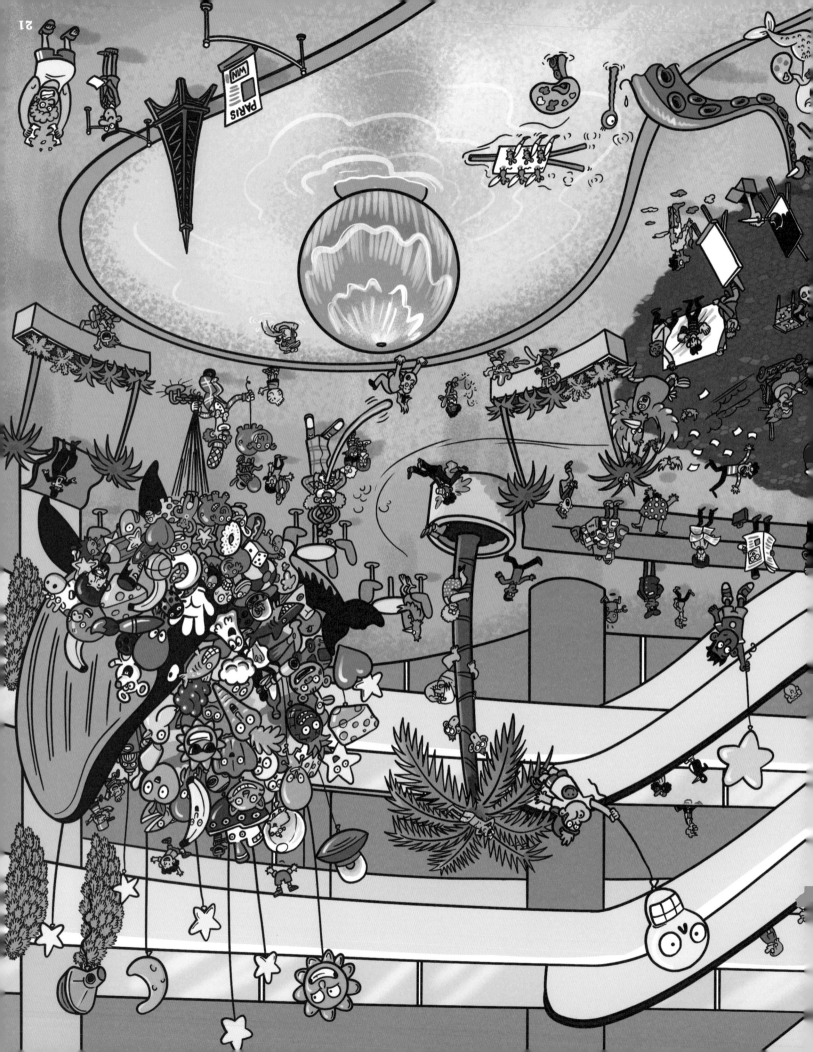

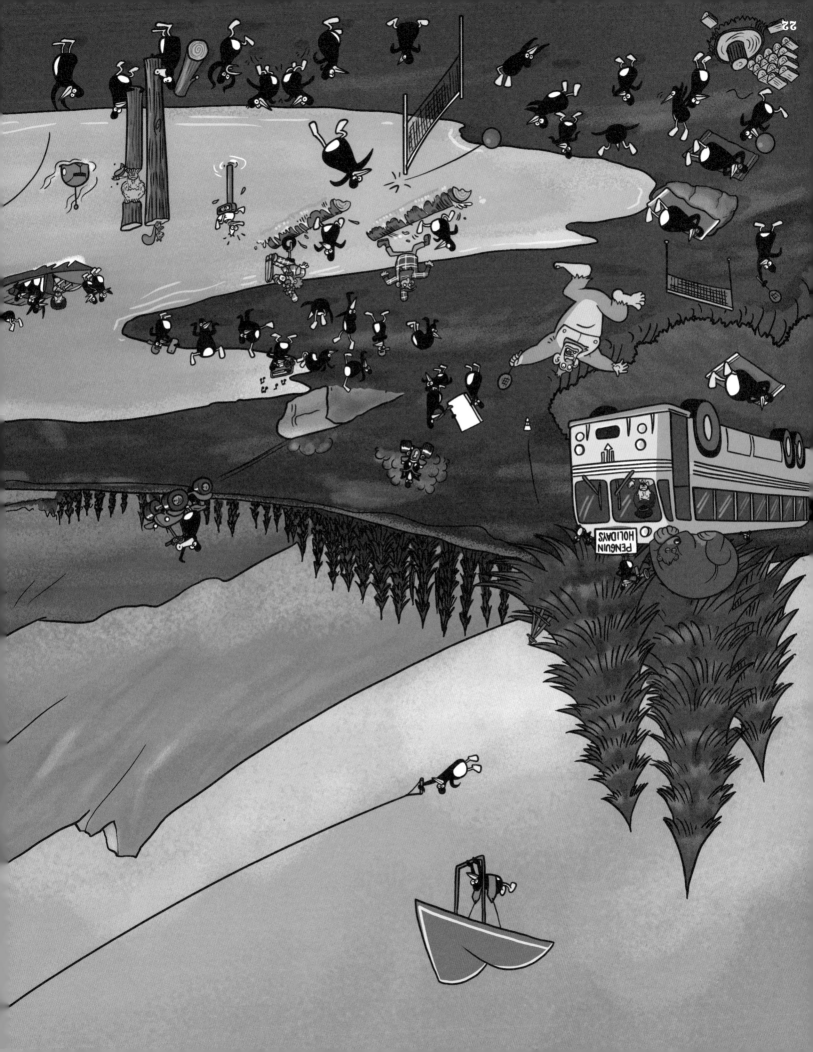

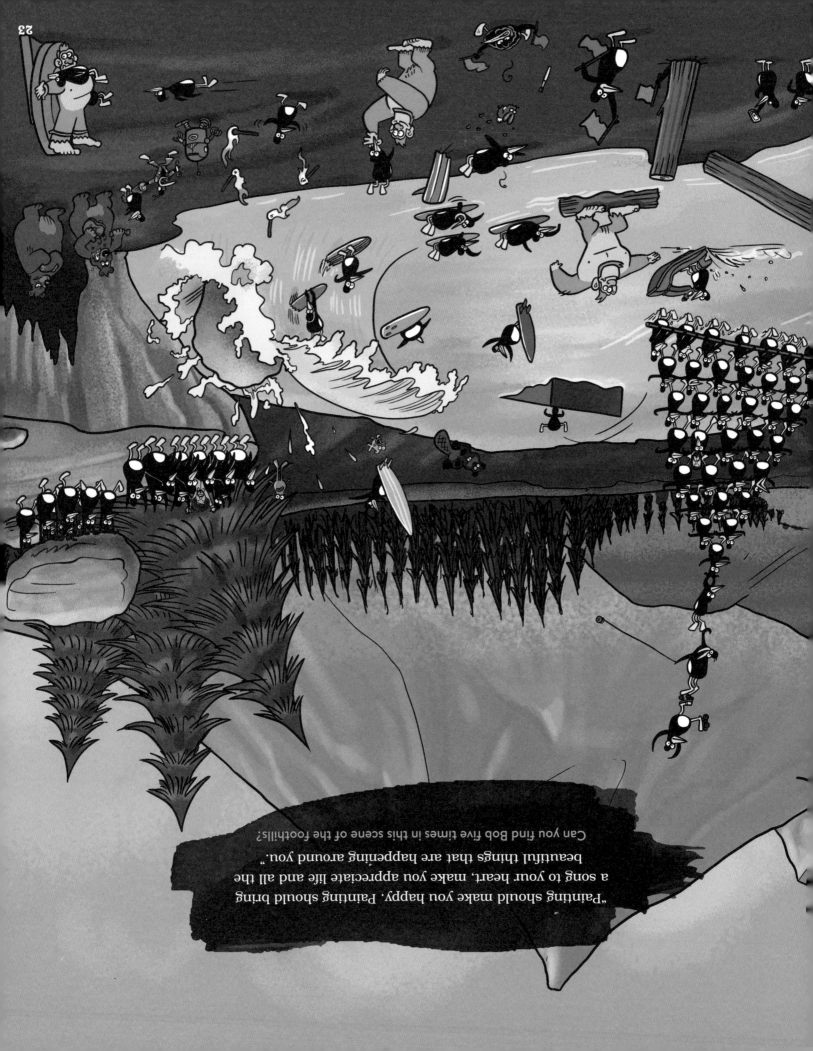

"Painting should make you happy. Painting should bring a song to your heart, make you appreciate life and all the beautiful things that are happening around you."

Can you find Bob five times in this scene of the foothills?

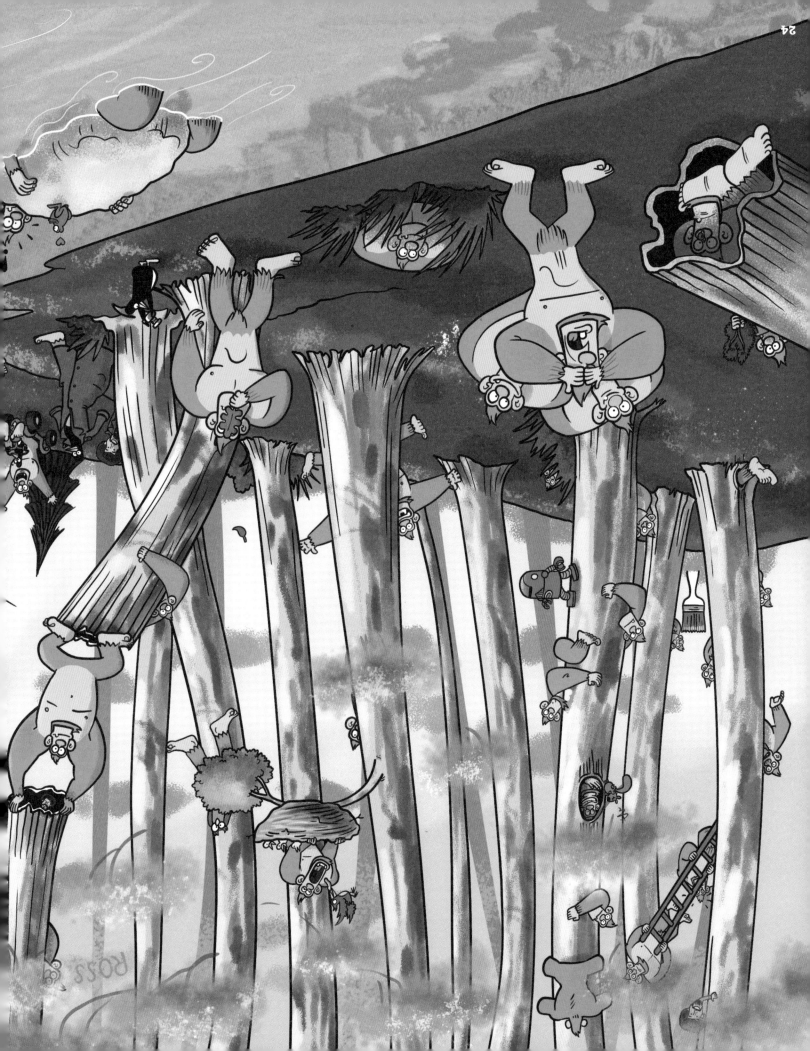

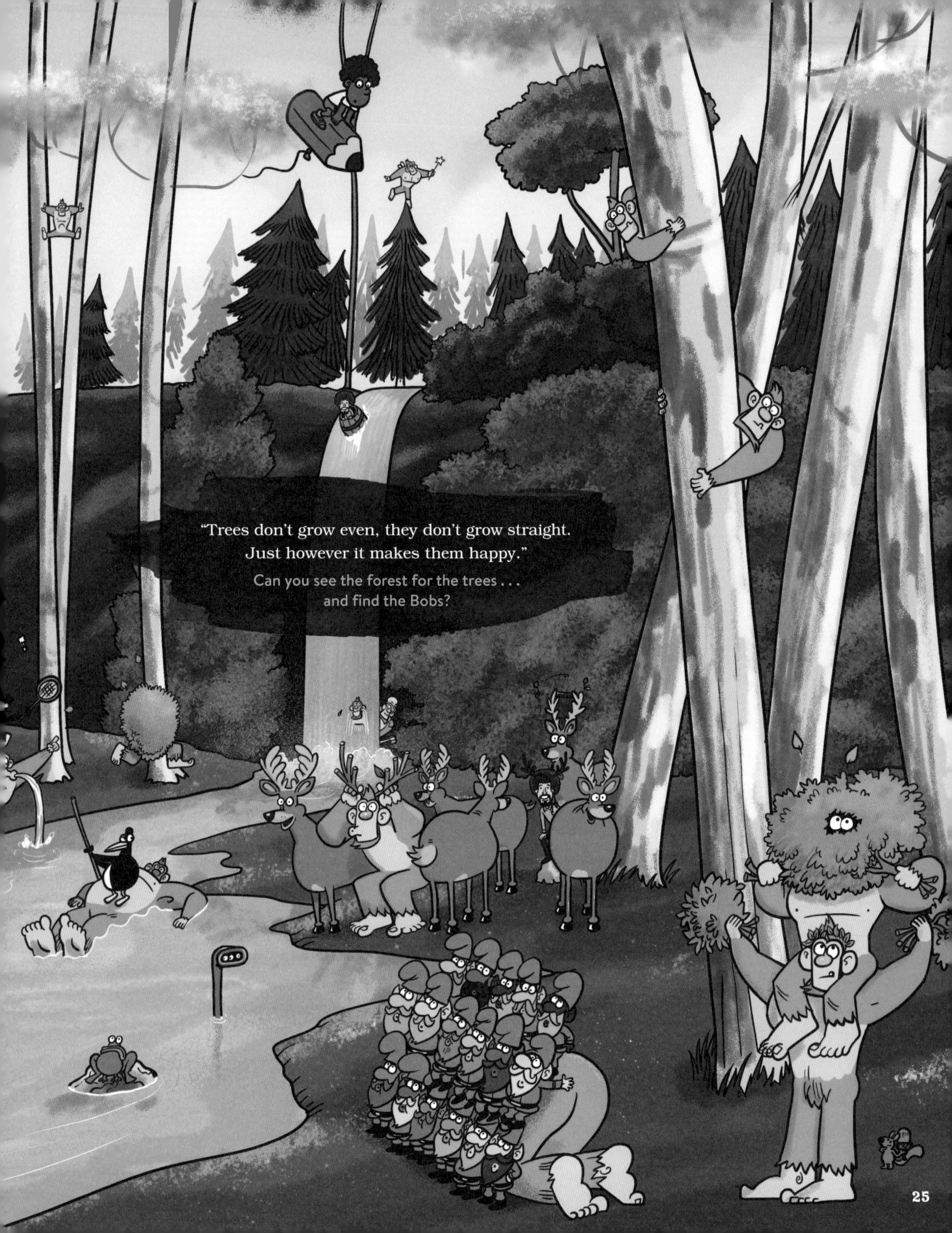

"Trees don't grow even, they don't grow straight.
Just however it makes them happy."

Can you see the forest for the trees . . .
and find the Bobs?

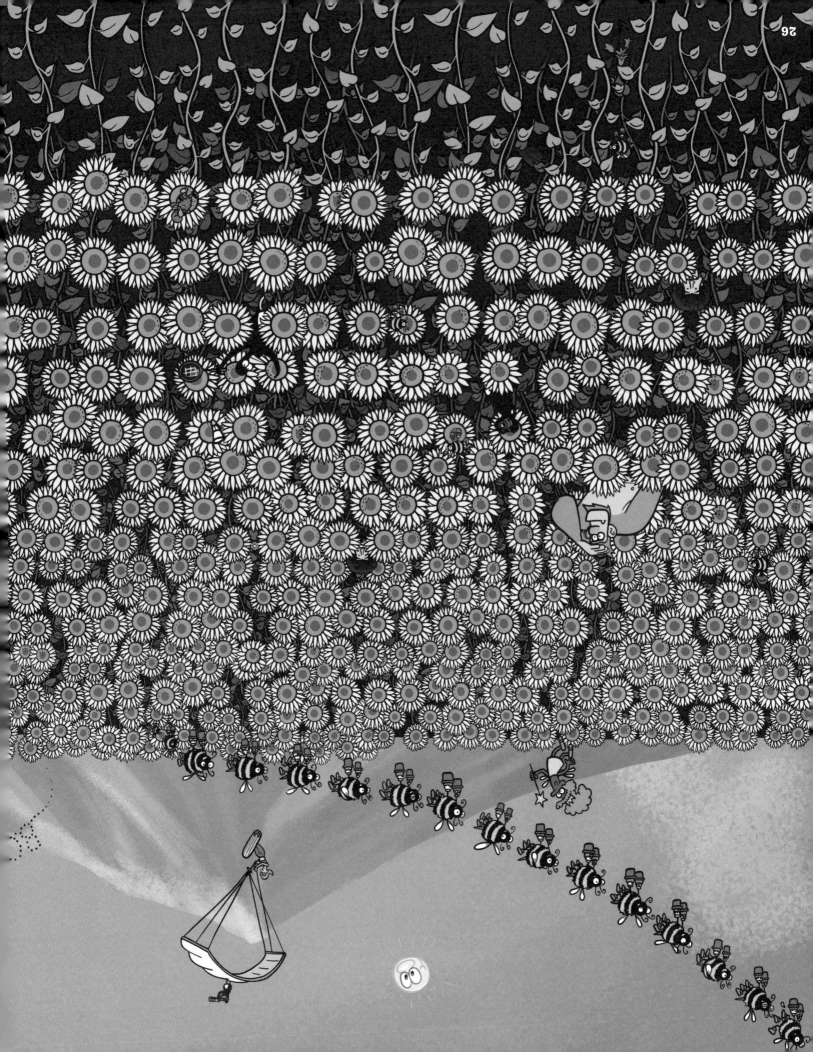

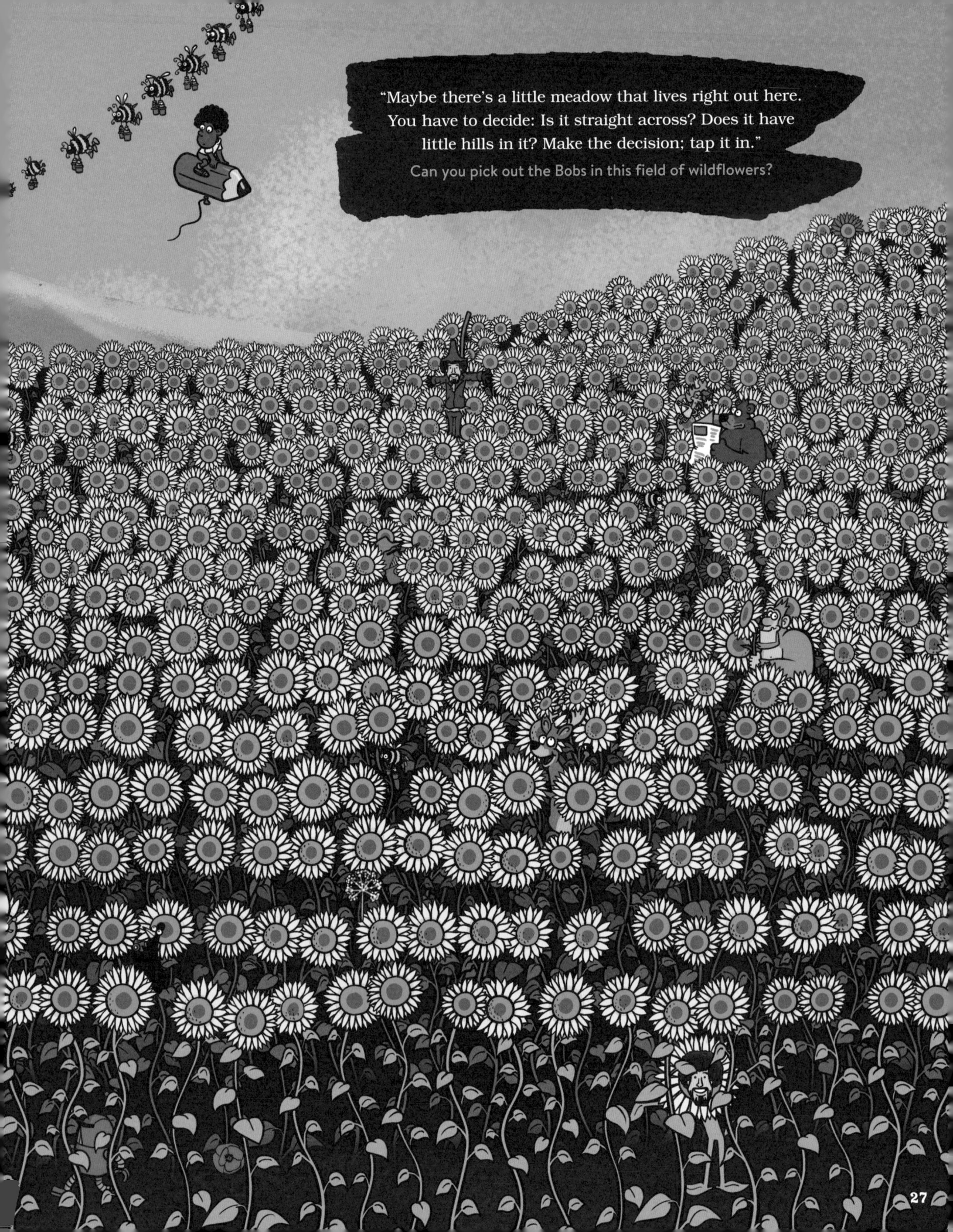

"Maybe there's a little meadow that lives right out here. You have to decide: Is it straight across? Does it have little hills in it? Make the decision; tap it in."

Can you pick out the Bobs in this field of wildflowers?

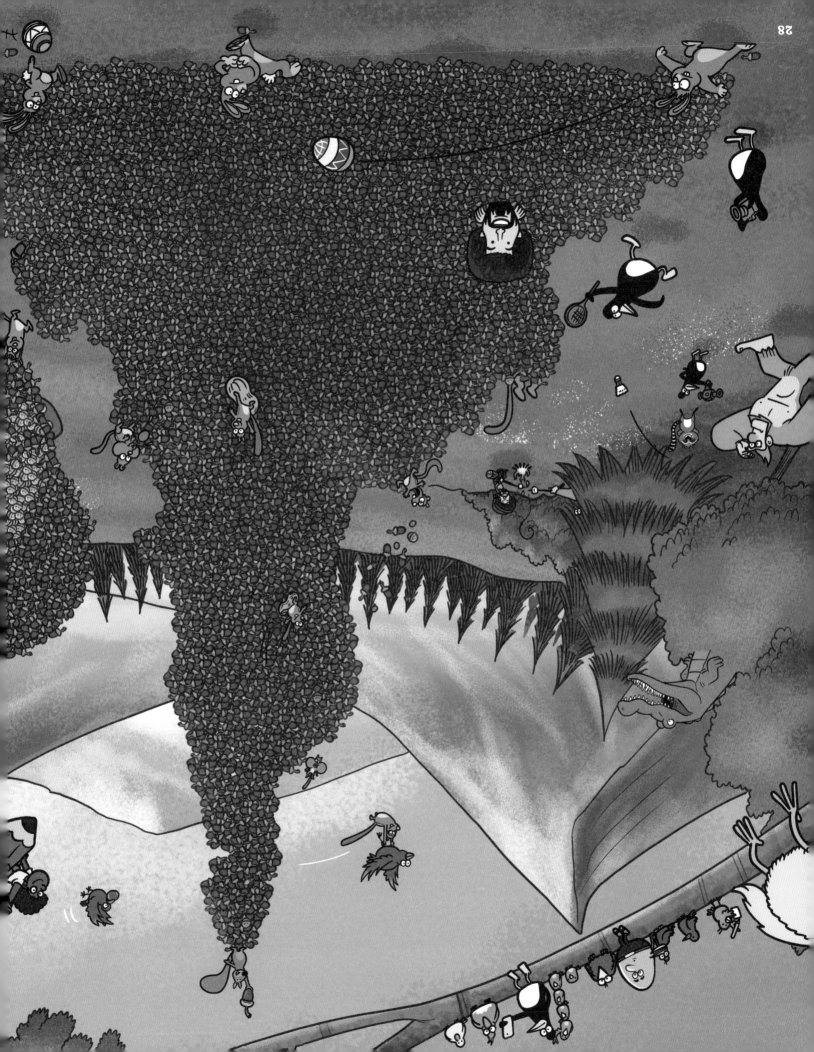

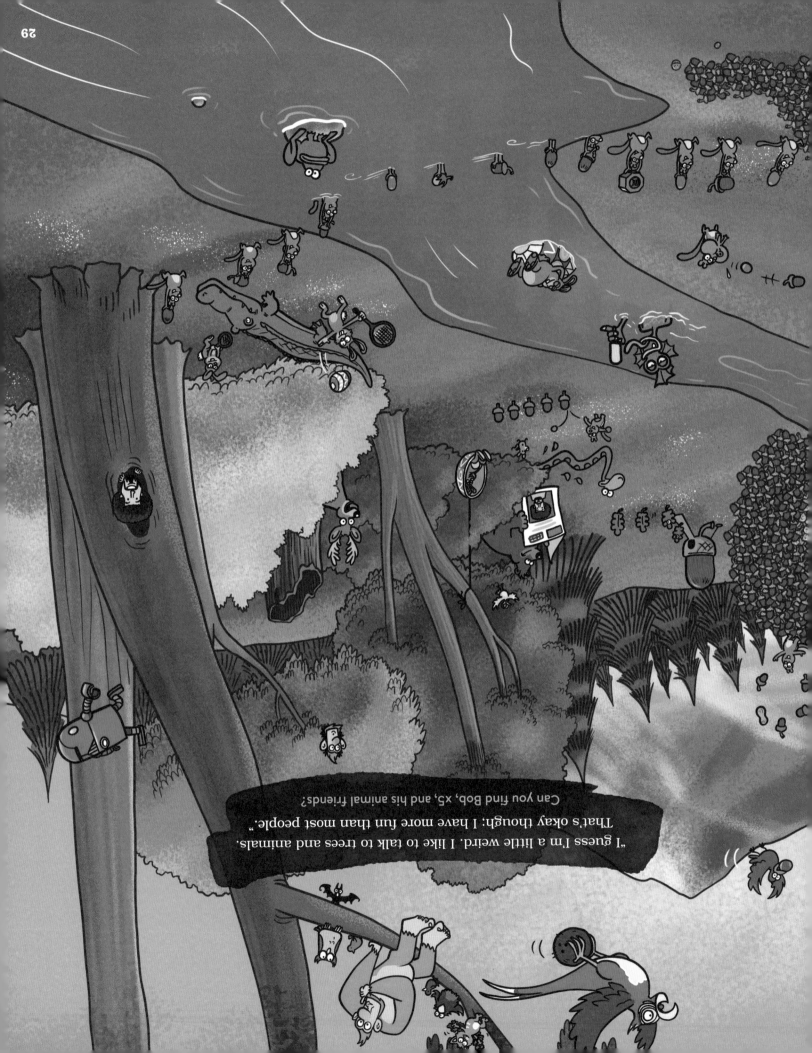

"I guess I'm a little weird. I like to talk to trees and animals. That's okay though; I have more fun than most people."

Can you find Bob, x5, and his animal friends?

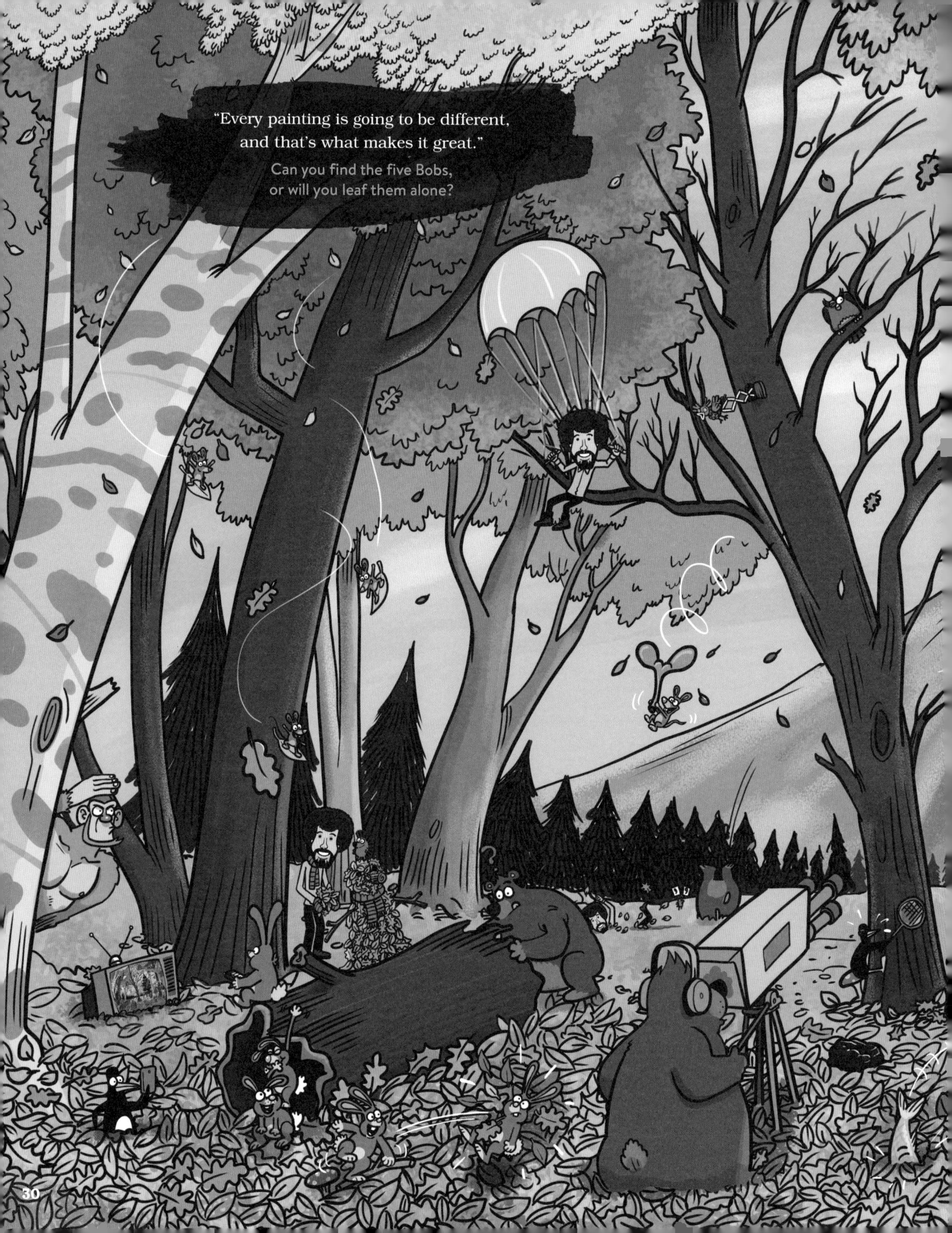

"Every painting is going to be different,
and that's what makes it great."

Can you find the five Bobs,
or will you leaf them alone?

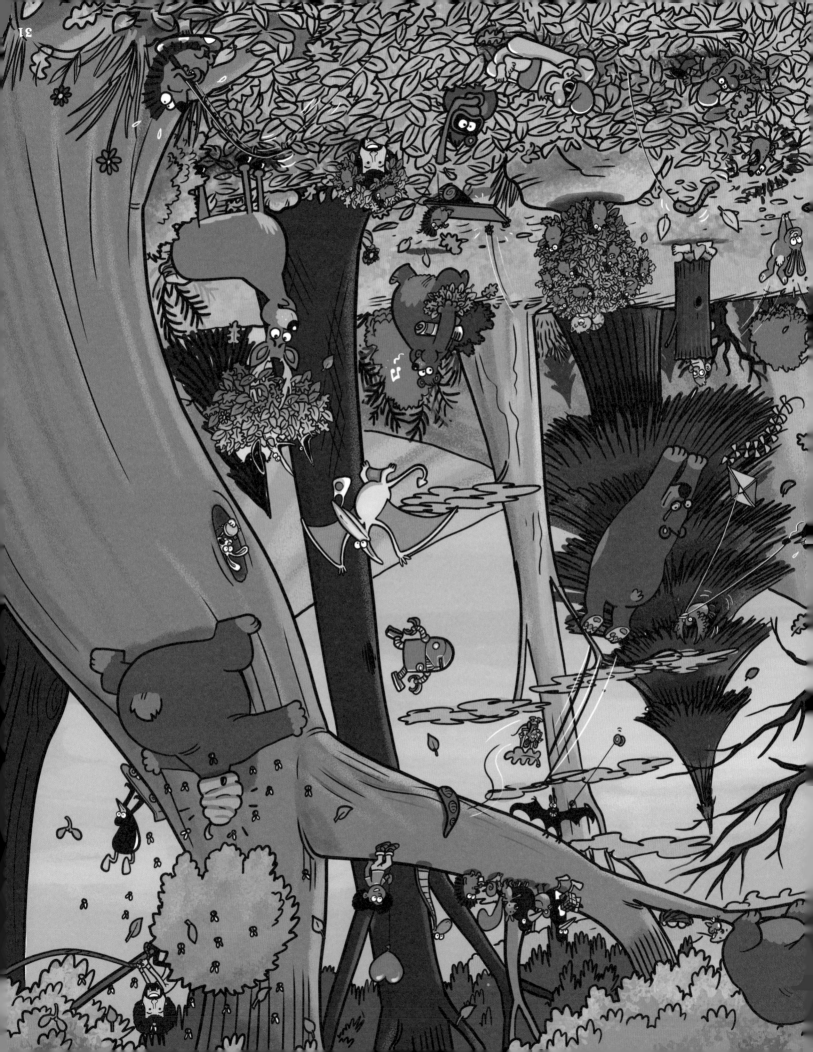

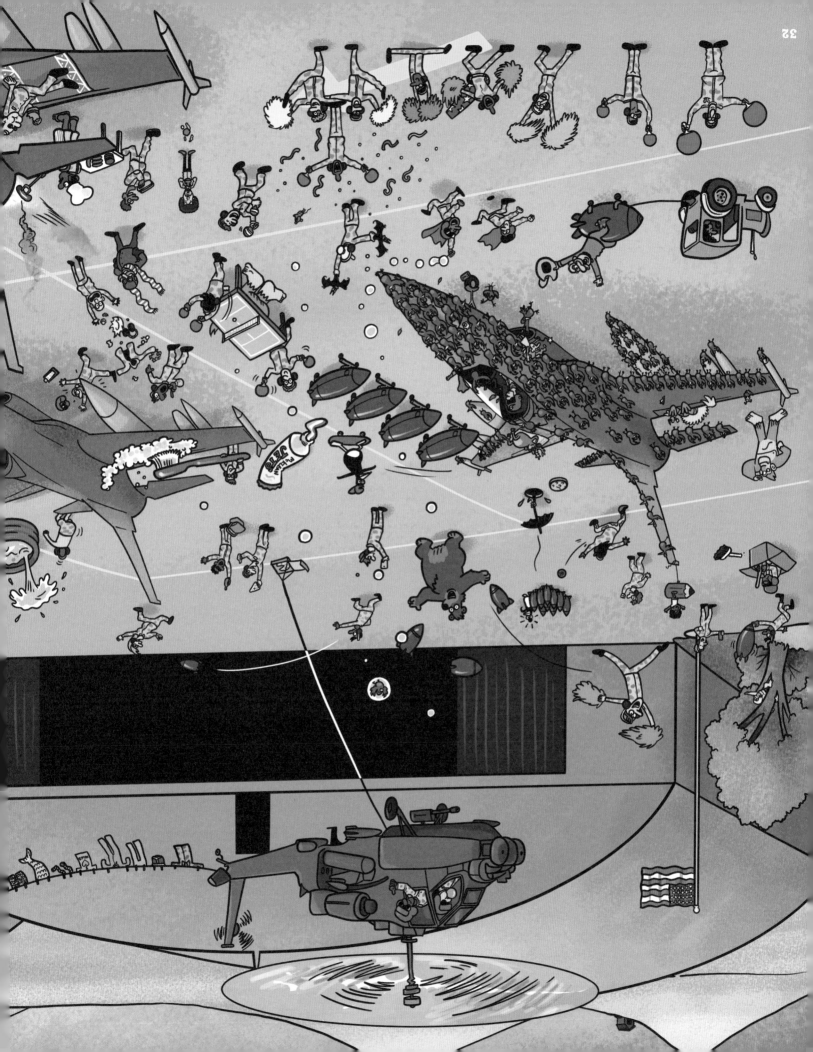

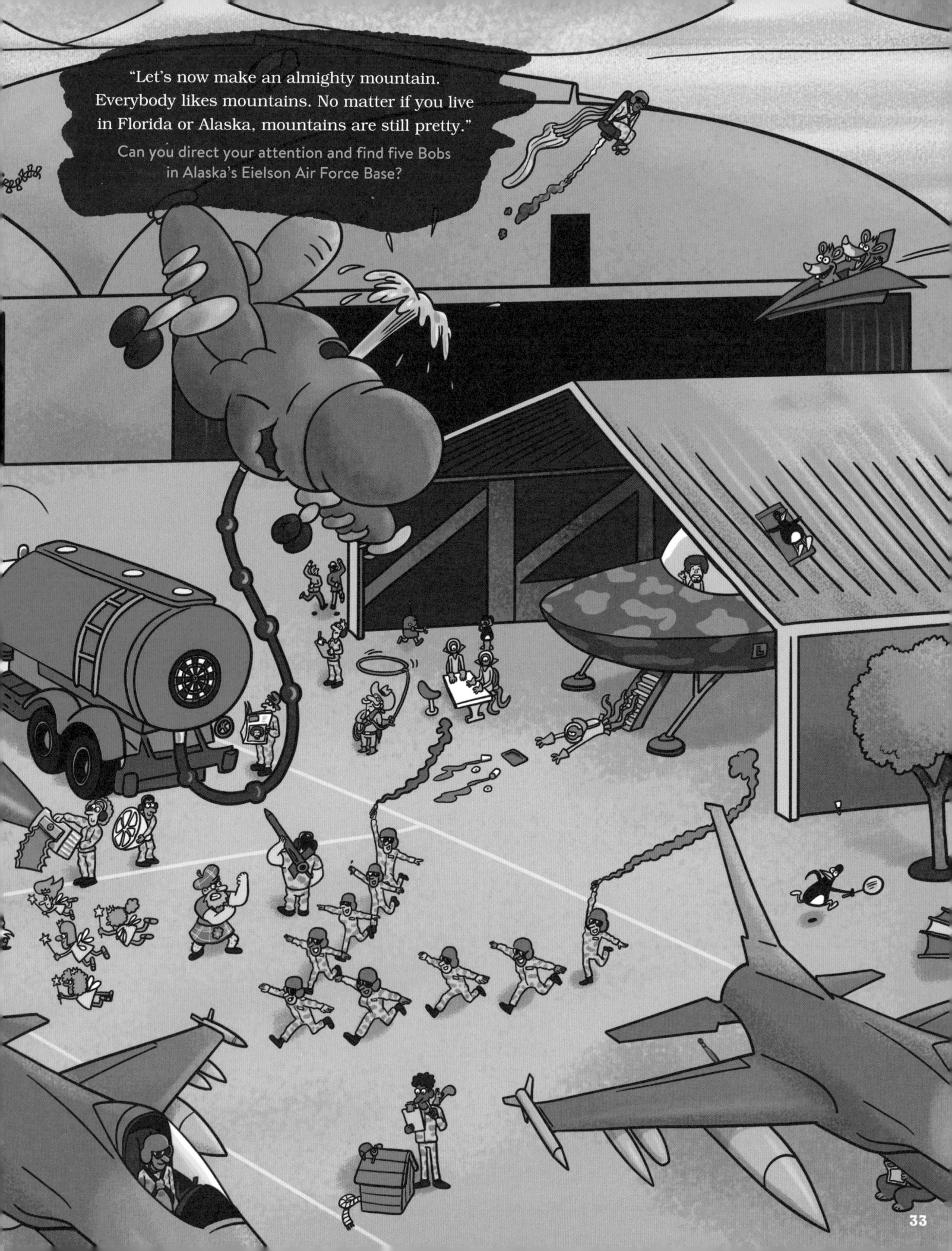

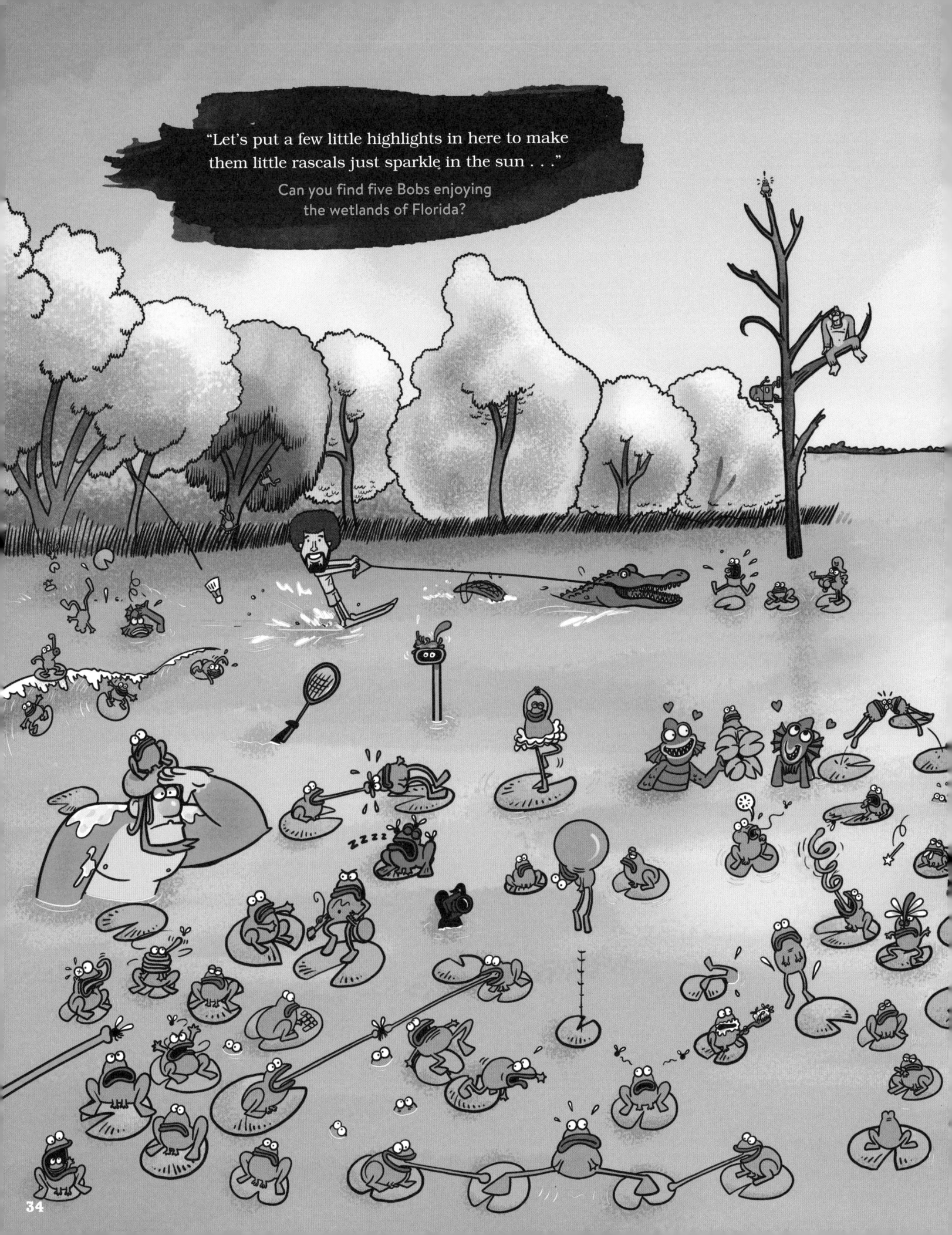

"Let's put a few little highlights in here to make them little rascals just sparkle in the sun . . ."

Can you find five Bobs enjoying the wetlands of Florida?

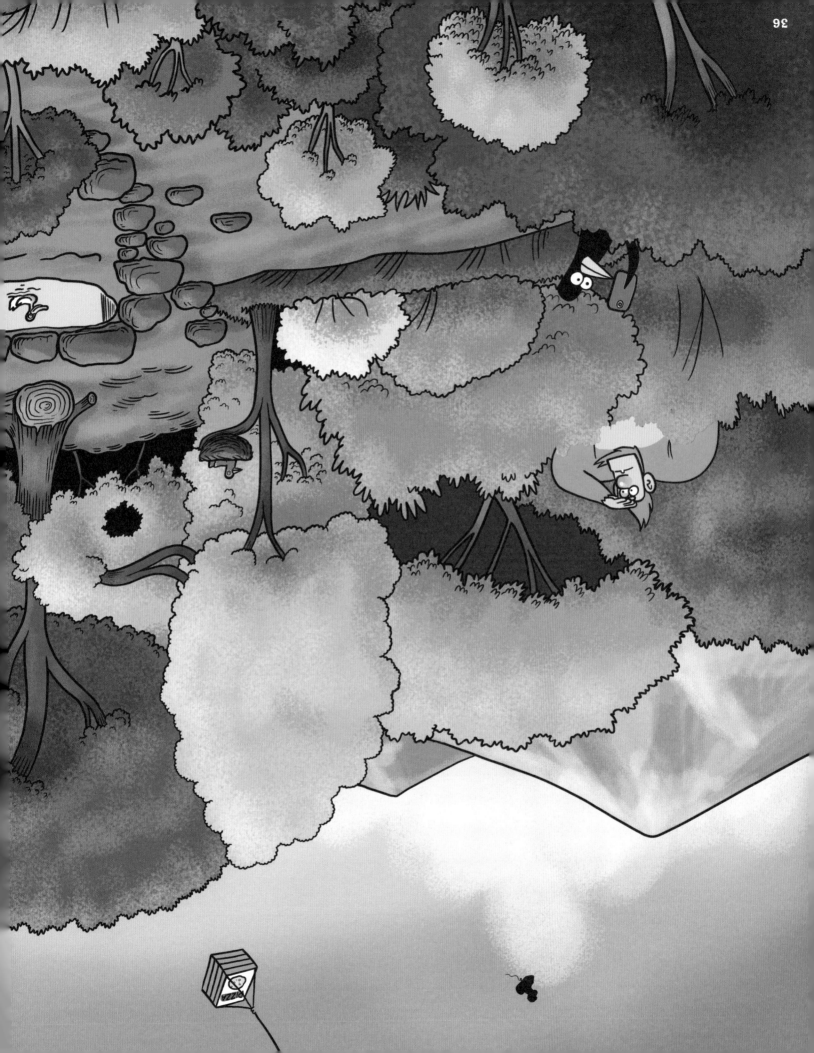

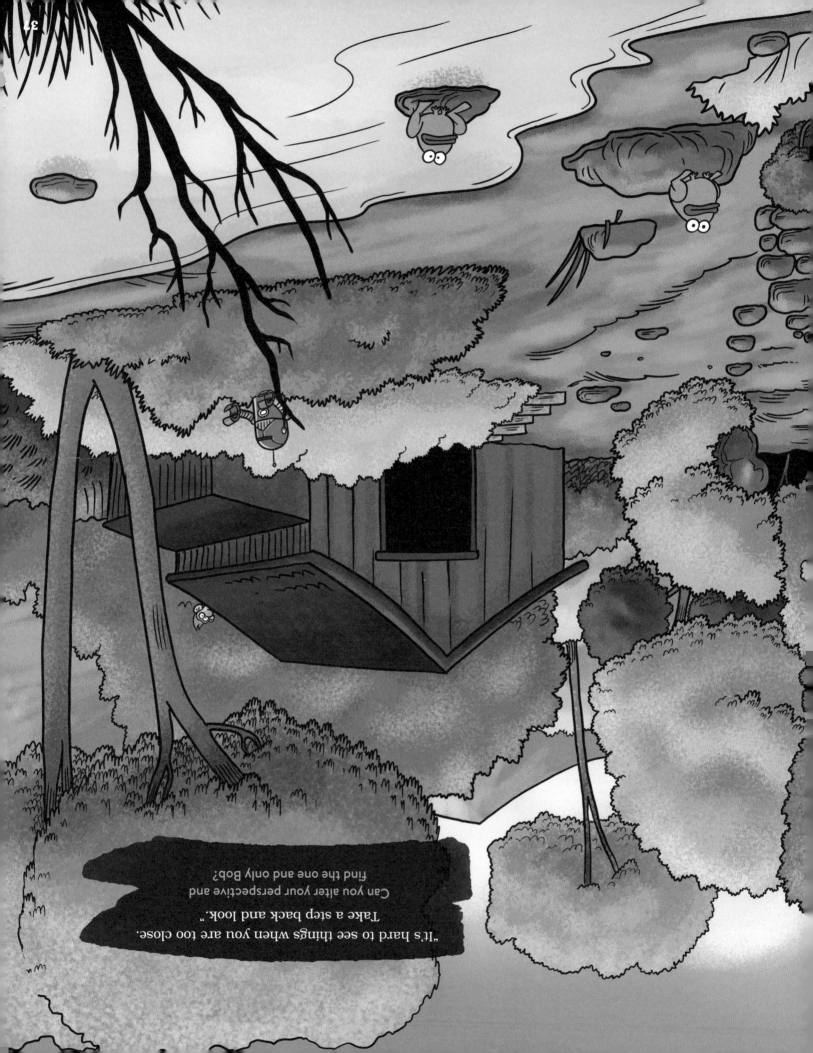

Checklists

You found Bob everywhere! Isn't that great? I knew you could do it.
Next round, have a look for these other items . . .

TV STUDIO
❏ Clacker
❏ Phthalo blue splatter
❏ WIPB TV logo
❏ Painting knife
❏ Paper towels

LAZY RIVER
❏ Happy cloud
❏ Alizarin crimson tree
❏ Blending brush
❏ Palette
❏ Two baby foxes
❏ TV

SEASIDE
❏ Peapod the squirrel
❏ Sap green starfish
❏ Fan brush
❏ TV clacker
❏ TV

MOUNTAIN RANGE
❏ Peapod the squirrel
❏ Indian yellow snowman
❏ Painting knife
❏ Air force plane
❏ WIPB TV logo

NIGHTSCAPE
❏ The word "BOB"
❏ Peapod the squirrel
❏ Phthalo blue Aurora Borealis
❏ Script liner brush
❏ Palette
❏ Raccoon

LUSH FOREST
❏ Peapod the squirrel
❏ Prussian blue bird
❏ Landscape Brush
❏ The word "BOB"
❏ Deer
❏ TV

SHOPPING MALL
❏ Alizarin crimson pants
❏ Van Dyke brown Vandyke beard
❏ Yellow ochre hat
❏ Phthalo green shirt
❏ Paint brush

ROLLING HILLS
❏ Peapod the squirrel
❏ Titanium white canvas
❏ Round foliage brush
❏ Rabbit
❏ Easel

DENSE FOREST
❏ Two squirrels
❏ Bright red leaf
❏ Background brush
❏ The word "ROSS"
❏ Owl

WILDFLOWER FIELD
❏ The word "BOB"
❏ Alizarin crimson sunflower
❏ Phthalo blue sunflower
❏ Bellflower
❏ Poppy
❏ Daisy
❏ Queen Anne's lace

ANIMAL FRIENDS
❏ Peapod the squirrel
❏ Raccoon
❏ Deer
❏ Two alligators
❏ Owl

THE WOODS
❏ Peapod the squirrel
❏ Midnight black rock
❏ Floral brush
❏ TV
❏ TV camera

AIR FORCE BASE
❏ Peapod the squirrel
❏ Palette
❏ Dark sienna uniform
❏ Blender brush
❏ Happy little tree
❏ Cabin

FLORIDA WETLANDS
❏ Peapod the squirrel
❏ Bright red frog
❏ Prussian blue frog
❏ Background brush
❏ The word "BOB"

WHERE'S BOB?
❏ Bob's face in the trees

Key

TV STUDIO

Most of the episodes of *The Joy of Painting* were filmed in a modest studio space in Muncie, Indiana. And though Bob painted each painting live, he also knew that practice was necessary for success. To make sure he was able to entertain and educate viewers within the allotted time, he painted at least three versions of the same painting before filming. Originally located in what was known as the Lucius B. Ball home, the studio is now a museum and part of a forty-acre Minnetrista complex in Muncie.

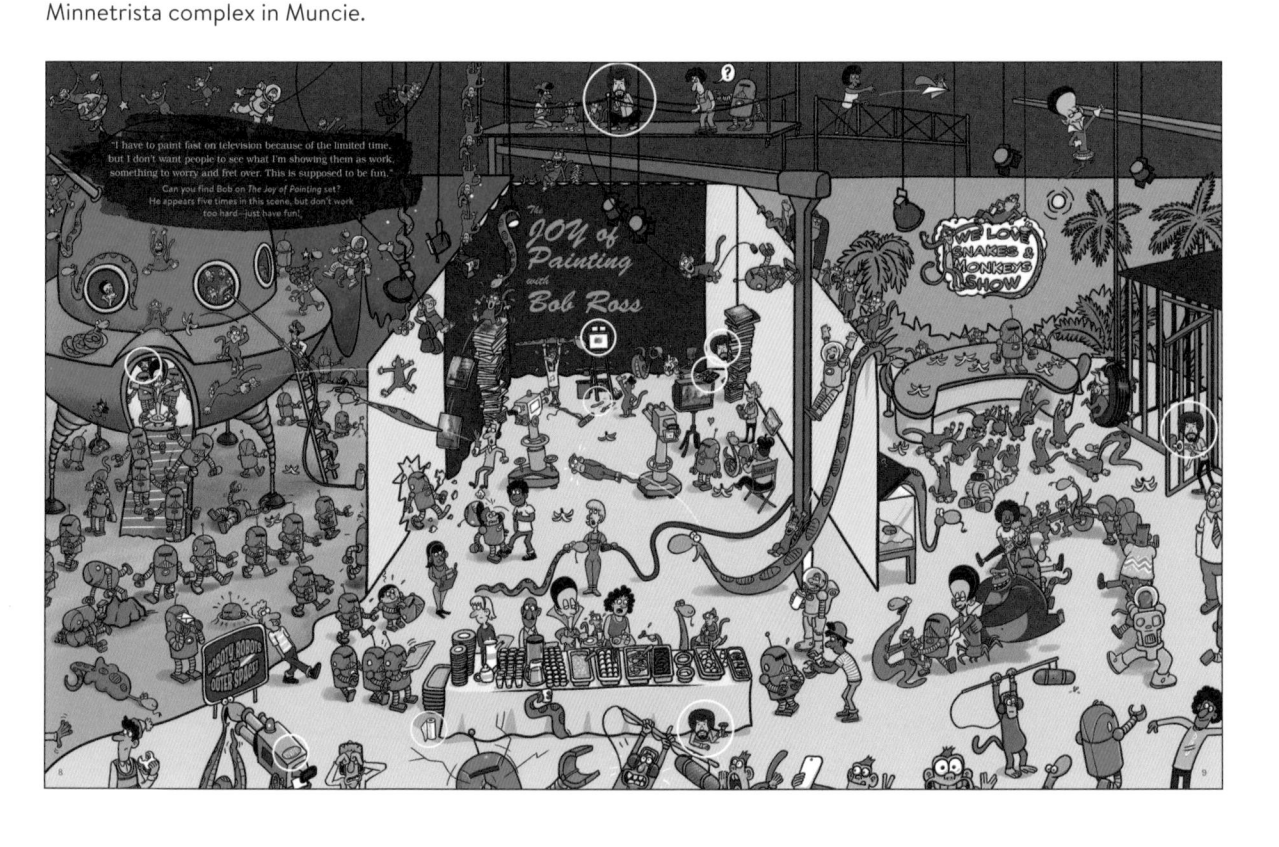

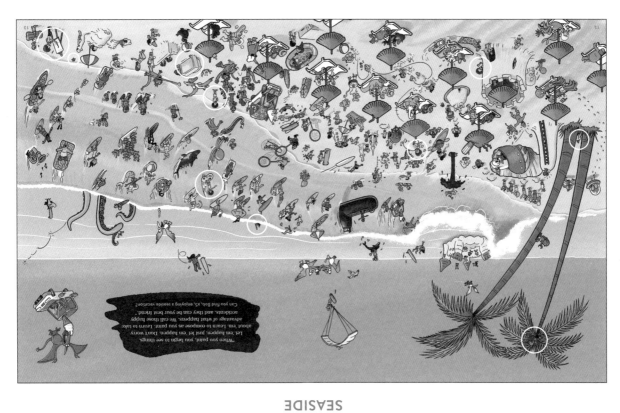

SEASIDE

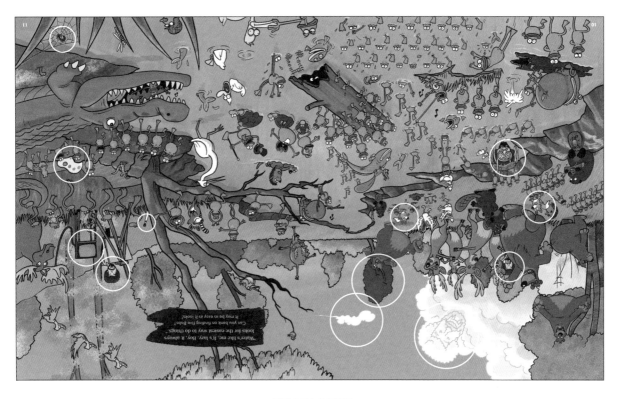

LAZY RIVER

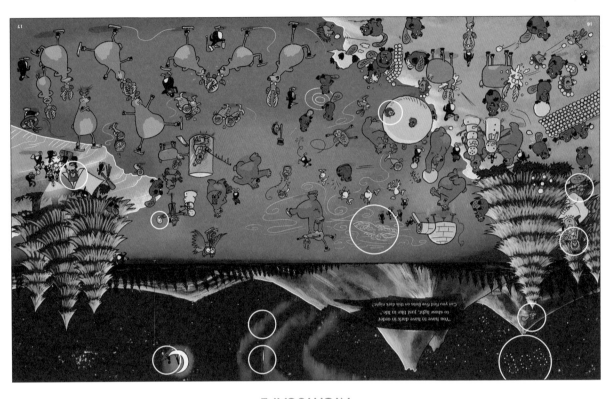

NIGHTSCAPE

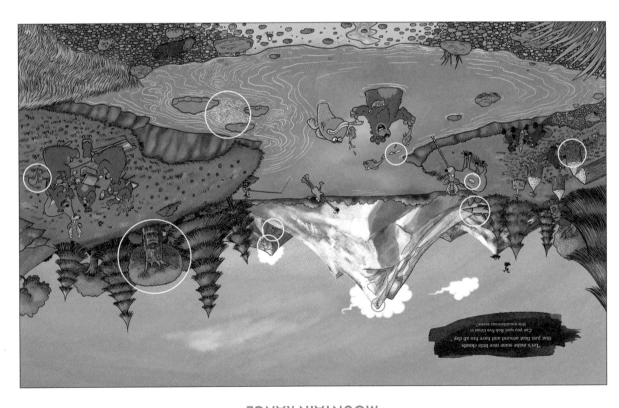

MOUNTAIN RANGE

LUSH FOREST

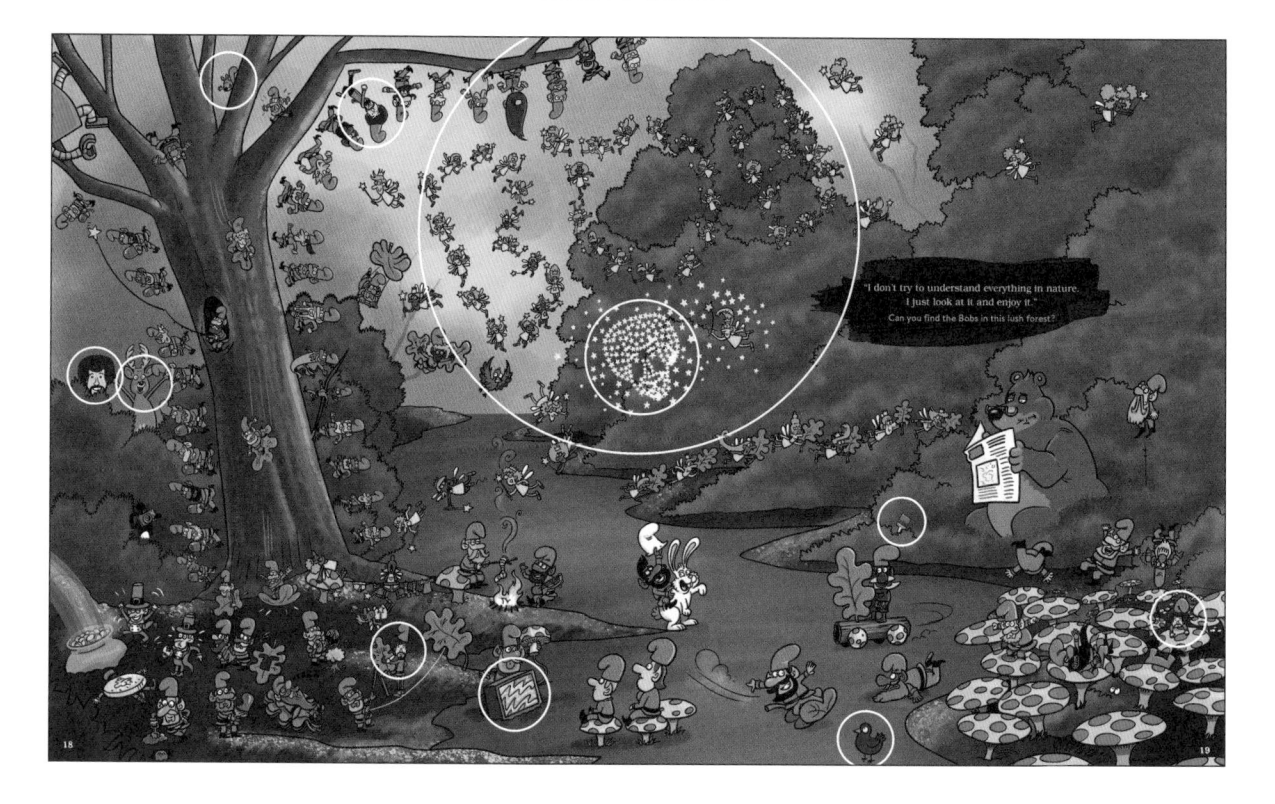

SHOPPING MALL

Bob often toured shopping malls across the country, where he demonstrated and taught his wet-on-wet technique. In crowds large and small, fans of all ages and abilities were able to connect with Bob, build their confidence, and embrace their inner painter.

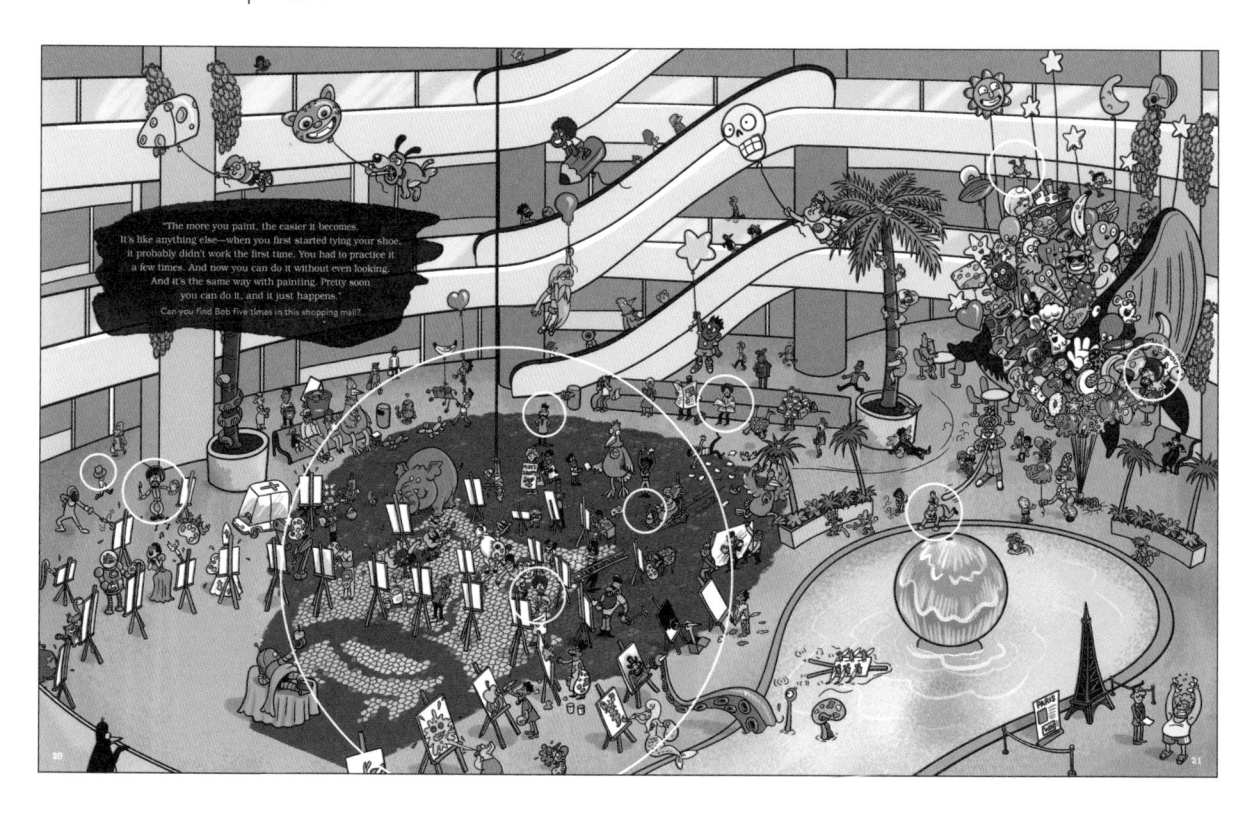

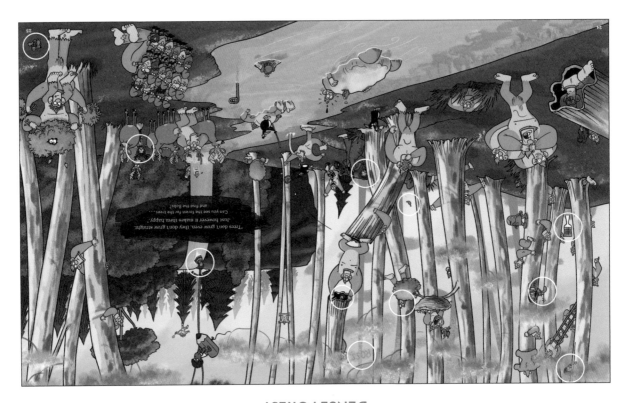

DENSE FOREST

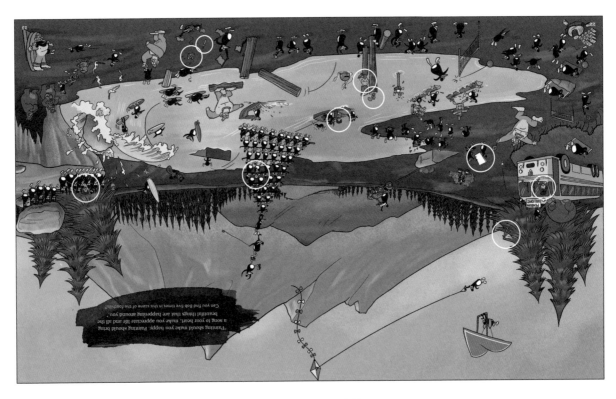

ROLLING HILLS

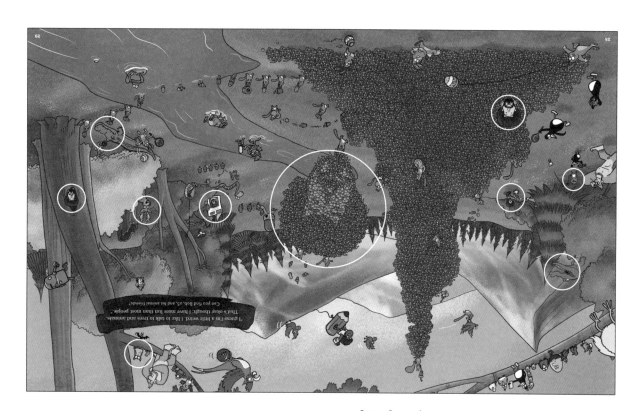

WILDFLOWER FIELD

ANIMAL FRIENDS

Bob was as much an animal lover as he was a painter and teacher. Though Peapod the Pocket Squirrel may have been his most famous furry friend, Bob's love and respect for animals began in childhood, when he often cared for sick and injured critters. And though he encountered a wide variety of animals in Florida, he often found himself meeting and enjoying the company of creatures native to other parts of the country. Whether in a city, a suburb, or the woods, Bob was a friend to every living thing!

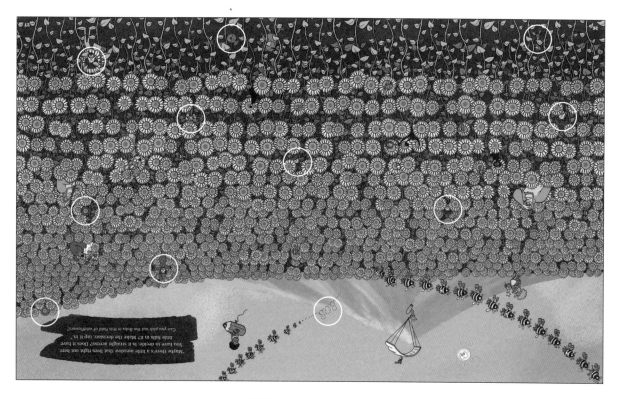

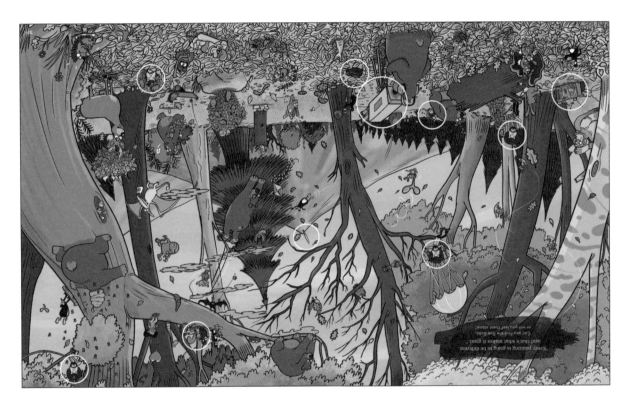

THE WOODS

AIR FORCE BASE

Bob enlisted in the air force in 1961. And though he certainly worked hard while he was stationed at Eielson Air Force Base in Alaska, he couldn't help but notice the natural grandeur and beauty surrounding him. Bob took art classes at the local U.S.O. club and watched Bill Alexander's television shows to learn how to express himself creatively. It was during this time he also learned which techniques, styles, and materials he preferred. His experience in the air force also informed the way he taught. In contrast to the high-pressured, systematic, and often loud on-base environment, Bob made sure that his classes were always calm, welcoming, and nurturing spaces.

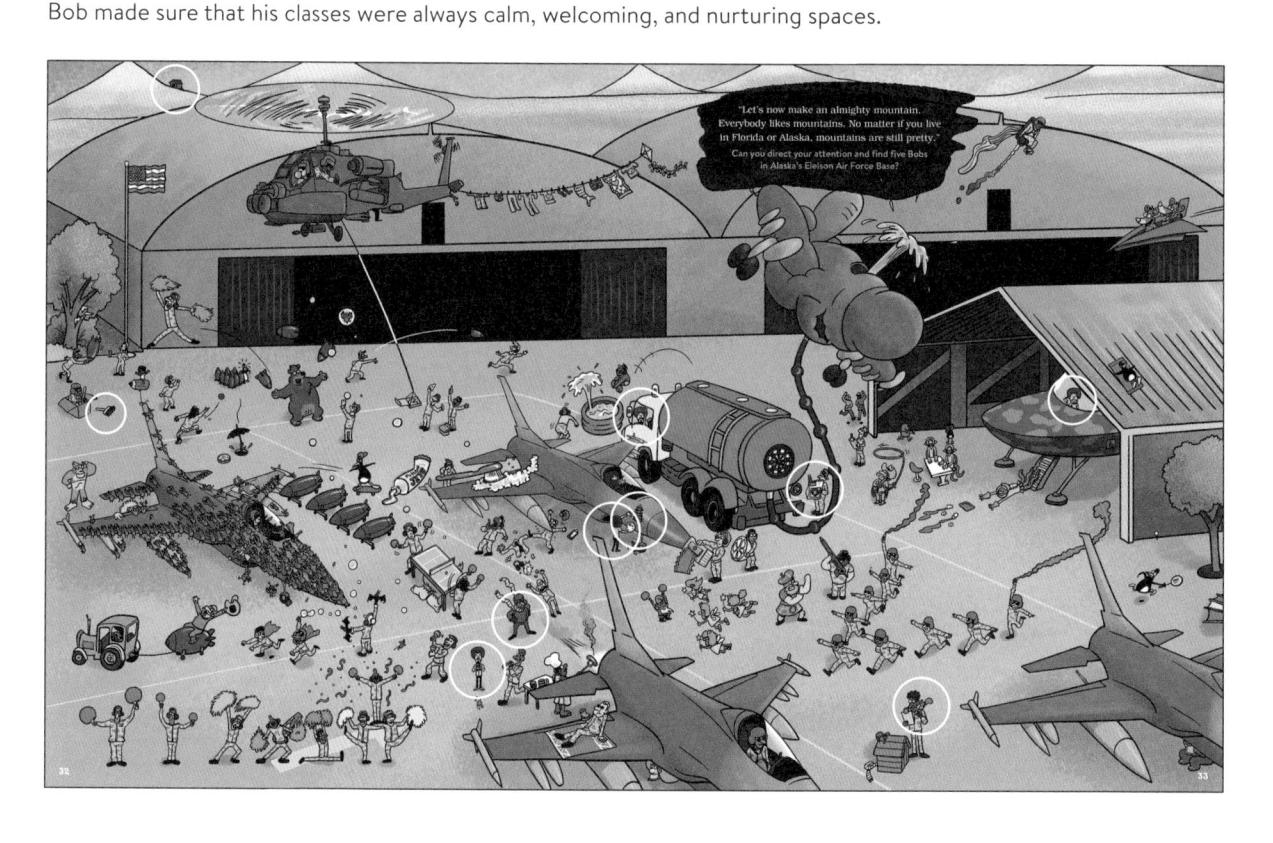

FLORIDA WETLANDS

Bob Ross was born in Daytona, Florida, on October 29, 1942. His parents, Jack and Ollie, raised him in Orlando. Bob left Florida when he was eighteen but returned before passing away at age fifty-two in 1995. His headstone reads, simply, "Bob Ross: Television Artist." But for the millions who love him, he was—and is—so much more.

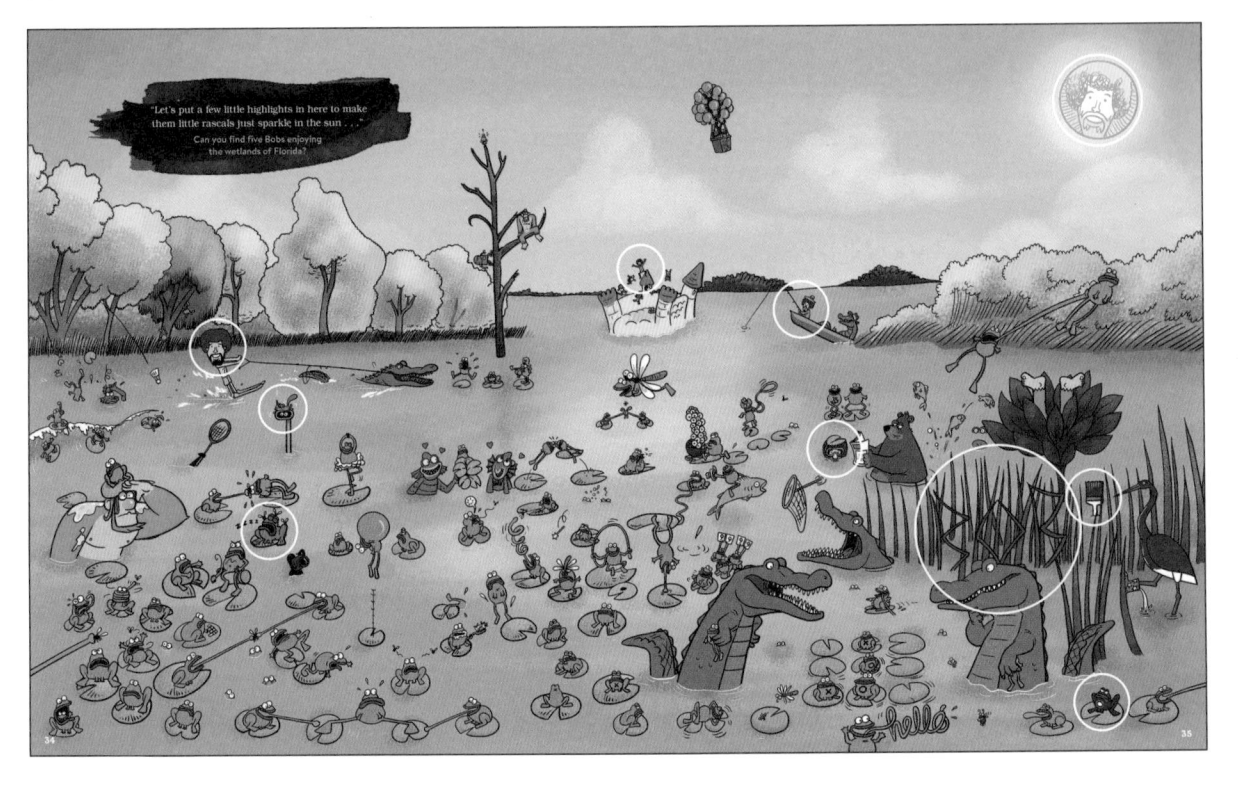

WHERE'S BOB?

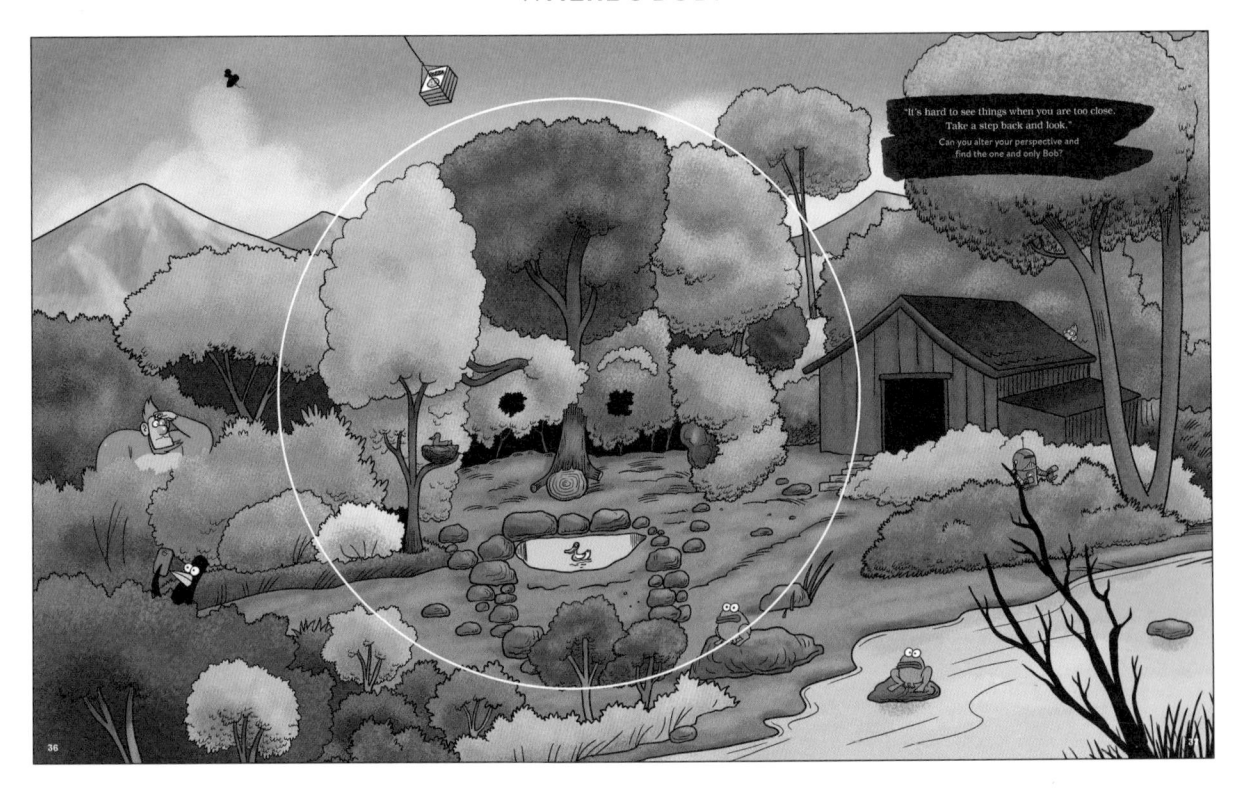

About the Author

ROBB PEARLMAN is a pop culturalist and a #1 *New York Times* bestselling author of more than fifty books for kids and adults, including *Bob Ross and Peapod the Squirrel*, *Bob Ross's Happy Little Night Before Christmas*, *The Bob Ross Cookbook*, *Life Lessons from Bob Ross*, *Search for Spock*, *The Office: A Day at Dunder Mifflin Elementary*, and *Live Like a Vulcan, Love Like a Wookie, Laugh Like a Hobbit*.

As a publishing professional specializing in pop culture titles, Robb is a featured speaker and panelist at pop culture conventions across the country. He serves on the Advisory Board of the MS in Publishing Program at Pace University. Visit him at robbpearlman.com.

About the Illustrator

BILL GREENHEAD is an illustrator and animator living in the beautiful Sussex seaside town of St Leonards-on-Sea. His cartoon illustrations have been published in the satirical humor magazine *Punch*, the British version of *Mad* magazine, and *The Times*. He has worked on many children's books, including *Superheroes of the United States Constitution: A Kid's Guide to American History Heroes*; *Charlie Smith, Superkid*; and the Hannah the Spanner series. He also animates for ecards, whiteboard projects, and much more.

Bill is happily married with three adult children, and in his spare time, he loves kayaking, sea-swimming, and watching movies.

KU-016-760